IMAGES
of America

GAINESVILLE
1900 TO 2000

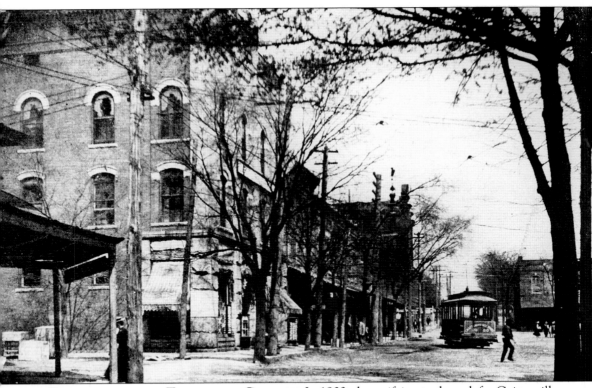

GAINESVILLE AT THE TURN OF THE CENTURY. In 1900, the unifying trademark for Gainesville could easily have been its street railway. Streetcars tied the town together—from the railroad station at the end of Main Street to the main square, and on to Chattahoochee Park on the river. Another line went from downtown to New Holland. The streetcar line was a major factor in Gainesville's golden era as the "Great Health Resort of the South," making it easy to go from one hotel to another, to the opera house, to ice cream parlors, and of course, to the various springs. Usage of the streetcars declined as the automobile evolved, and in 1928 some of the tracks in downtown were removed for road improvement. During World War II, the remainder of the tracks were pulled out and sold as scrap iron for the war effort.

IMAGES
of America

GAINESVILLE
1900 TO 2000

FOR Doris S. Prine

Gordon Sawyer

On behalf of Regions Bank, we
welcome you to Lanier Village Estates.
As you know, Gainesville is a unique
and wonderful town, and we thought
you would enjoy knowing more about
its history and culture.

ARCADIA

Gordon Sawyer

First published 1999
Reprinted 2000, 2001, 2005

Published by Arcadia Publishing
Charleston SC, Chicago IL, Portsmouth NH, San Francisco CA

Printed in Great Britain

For all general information contact Arcadia Publishing at:
Telephone 843-853-2070
Fax 843-853-0044
E-mail sales@arcadiapublishing.com
For customer service and orders:
Toll-Free 1-888-313-2665

Visit us on the internet at http://www.arcadiapublishing.com

CONTENTS

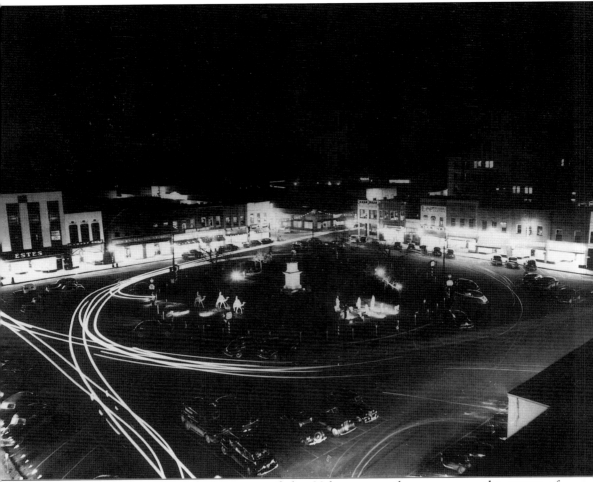

THE GAINESVILLE SQUARE. For most of the 20th century, the square was the center of commercial and social activity in Gainesville and Hall County. In this 1950s picture, with a Christmas nativity scene, note that the center of the square is round. One of the historic characteristics of the Gainesville square is that, every so often, it has been revised, remodeled, and redecorated.

INTRODUCTION

Gainesville: 1900-2000 includes images of how this area looked and how we lived during the last 100 years. The 20th century has brought about some spectacular changes. They are all being duly recorded in the news media and on television. All of those changes have affected us here at the local level.

But this is not intended to be a narrative history; a chronological listing of what happened and when. We will save that for another book.

This book is a collection of almost 200 images of Gainesville and Hall County during the last 100 years. The pictures came from many sources, although the largest single sources have been the Hall County Library and the State of Georgia Archives in Atlanta. We attempted to select the pictures that told the story of how we looked and how we lived, about how Gainesville and Hall County changed over the course of a century.

It is fair to say the largest problem in putting this book together has not been in acquiring pictures, but in selecting those pictures that, together, will give us a reasonably accurate image of Gainesville from the year 1900 until the year 2000.

The photographs here will not document all of the important events in Gainesville and Hall County over the past century, and certainly it will not show all of the important people. What I hope is that, as you thumb through these pages, you will be able to say warmly, "I remember that." And more importantly, that your children and grandchildren will be able to say: "Now I understand our people and this community a little better."

I sincerely hope you have as much fun with *Gainesville: 1900-2000* as I have had putting it together.

Gordon Sawyer

ACKNOWLEDGMENTS

Compiling a photographic history, I have found, is different. One can research and outline the story to be told, but from that point on, the history is driven by the pictures available and the images they cast. Many of the pictures in this book were available because people before me had the good sense to capture and save the images that tell the story of how we looked and how we lived.

First and foremost, I want to recognize the pioneer professional photographers who made Hall County pictures in the first place: Leonard Cinciolo, Ed Beazley, N. C. White, Massey Studio, and Ramsey Studio. They were true artists, way ahead of their time.

The Hall County Library, under the dedicated prodding of Sybil McRay, deserves first credit for recognizing the value of these old images and fighting to preserve them. This tradition, thankfully, is being carried on by Ronda Sanders and Librarian Susan Stewart.

A delightful surprise I encountered during the course of the project is the magnificent collection of old photographs at the Archives of the State of Georgia entitled "Vanishing Georgia." Hall County is well represented in this collection—thanks again to the local library and Sybil McRay. At the Archives, Gail Miller DeLoach, who is in charge of the photographs, is a true professional and a willing helper.

Michael Wood is a professional photographer I had known in the advertising business, but as this book evolved he became an invaluable counselor and co-author. Not every photo in this book is great, but I will assure you every great photo has the imprint of Michael Wood. He is a true magician when it comes to resurrecting old, faded photographs.

So many more people helped that it is dangerous to mention any of them, for many will be left out, but I am going to do it anyway: Barbara Webster, Henry Ward, Joanne Frierson, Heyward Hosch, Doug Payne, Martha Byrd, Earl Pittman, Don Brice (whose father wrote the book on the Tornado of 1936), Bob Adams, John Vardeman, Haydee Anderson, Gene Beckstein, Paula Moore . . . I'm in big trouble, because that's just the beginning.

The point is simple: I had the privilege of putting this book together, but it belongs to the people of Gainesville and Hall County . . . and a great many of them participated in its construction.

Gordon Sawyer

One

THE WAY WE LOOKED, THE WAY WE LIVED

1900–1950

America was different in 1900. Gainesville and Hall County were different. It was truly another age. This region was rural and agricultural, yet there was a certain sophistication to the city. Streetcars. Colleges. Fine Homes. Of course, there was the dirt-poor side, too.

The first 50 years of this century saw dramatic changes, locally as well as nationally—some good, and some bad.

Quality photographs from this era are not easy to come by, it turns out. This is partially due to the fact that photography was still in its developing stages in the early part of the century. Also, not many people have methodically kept pictures of anything other than their families. Even so, I invite you to watch as the first half of the century unfolds within these pages.

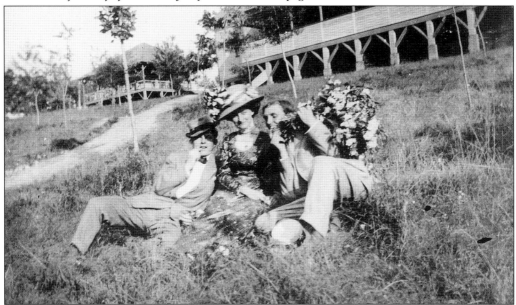

SUNDAY OUTING AT CHATTAHOOCHEE PARK. Young people pose below the pavilion during a Sunday outing at Chattahoochee Park, probably about 1910. People traveled by streetcar from all over Gainesville, and out Riverside Drive to the park for picnics, outings, dances, and fun. Launches and boats could be rented at the park.

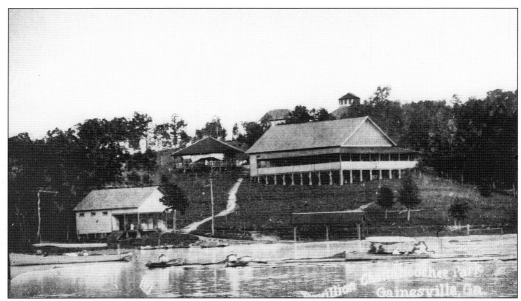

MOUNTAIN RESORT PLAYGROUND. (Above) Gainesville's reputation as a resort town was enhanced in 1908 when Dunlap Dam was built on the Chattahoochee River, creating Lake Warner. The Dam was privately constructed, along with a hydroelectric plant, to furnish electricity to the area. Later, the company combined with others to form Georgia Power Company. Chattahoochee Park, on Lake Warner at the end of Riverside Drive, was easily accessible by streetcar and became one of the region's most popular recreational areas. (Below) A streetcar is pictured downtown.

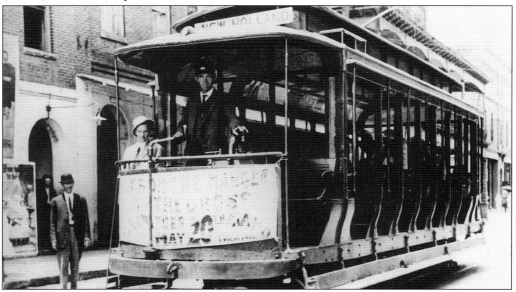

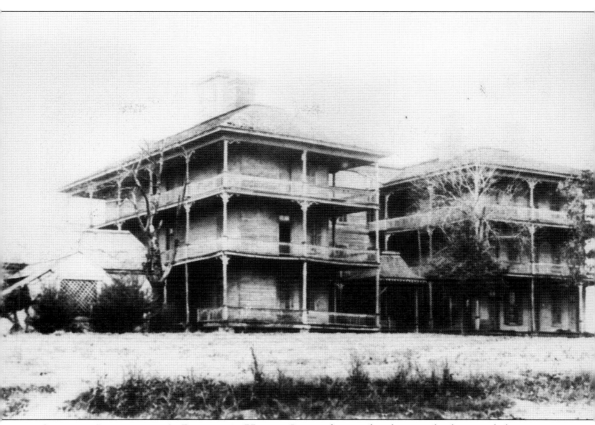

GENERAL LONGSTREET'S PIEDMONT HOTEL. Located near the depot, which served the main north-south railroad, this classic mountain hotel was a vital part of Gainesville's resort activities when this photo was taken about 1903.

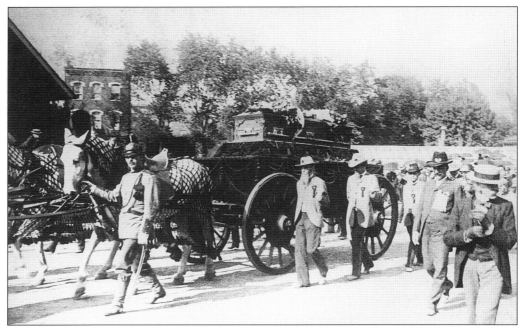

GEN. JAMES LONGSTREET. Personal memories of the War Between the States were dimming as the 20th century began. The Confederacy's legendary Gen. James Longstreet had moved to Gainesville after the war, operating the Piedmont Hotel and expecting Gainesville to become the railroad hub of the Southeast. The above picture is thought to be that of General Longstreet's 1904 funeral procession through Gainesville.

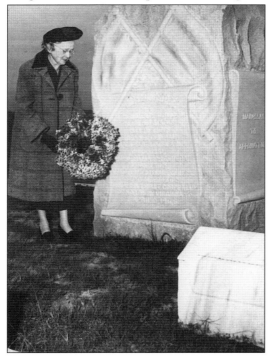

LONGSTREET'S WIDOW. Much younger than the General, Helen Dortch Longstreet placed this wreath on her husband's grave in the 1940s. She made news during World War II working in the Bell bomber plant.

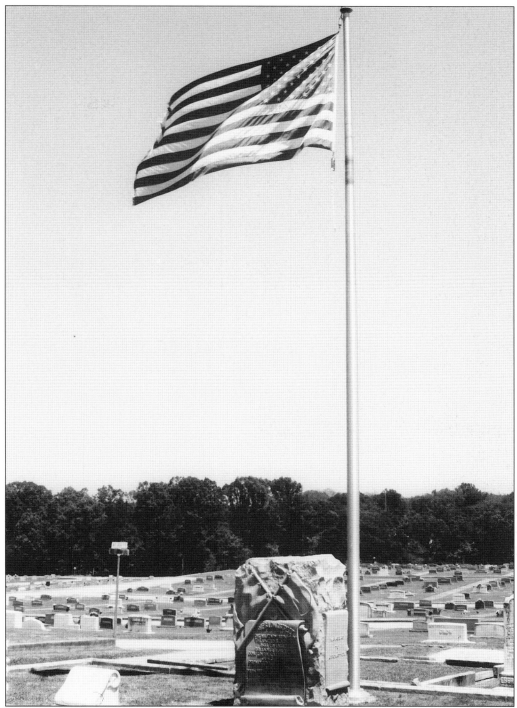

LONGSTREET'S GRAVE. The Confederate General is buried in Gainesville's Alta Vista Cemetery, suitably under a U.S. flag. He received severe criticism in the South during the late 1800s for his pro-Union stance and Republican political views in a solidly Democratic region.

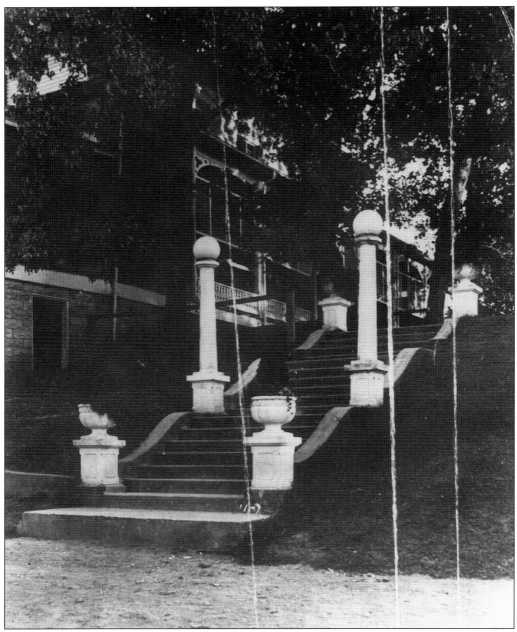

A RESORT FOR THE RICH. While the downtown area of Gainesville was a summer playground for everyone, the wealthy planters, merchants, and ship captains of the coastal South came to White Sulphur Springs, six miles North of Gainesville. It was a posh resort community featuring a large wooden hotel with wide porches; rooms (with baths) for more than 100 persons; and 40 guest cottages, which could accommodate up to 10 people each. It brought in dance bands from New York for its ballroom, and featured world-renowned dining. The hotel flourished until 1929 when it was closed, and fire took it down in 1933. Pictured are steps up to the hotel from the fabled springs, widely promoted for "marvelous cures."

14

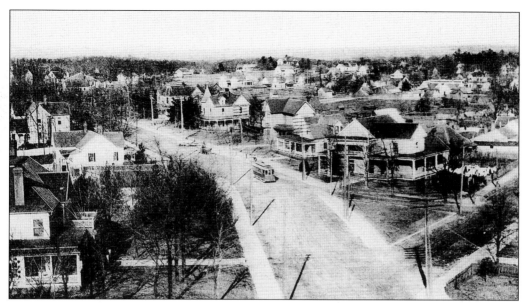

GREEN STREET. (Above) Pictured here is a 1907 view of Green Street from the tower of the newly built First Methodist Church. Note the streetcar. (Below) This photo shows Green Street nearer the square, with the presbyterian church on the right and the methodist church on the left. Streets were unpaved.

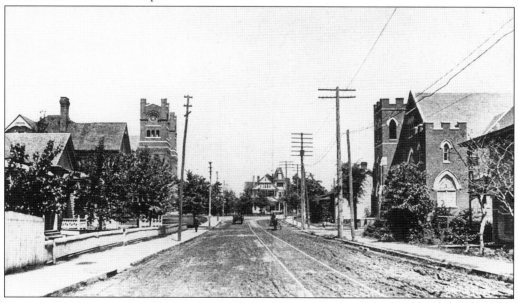

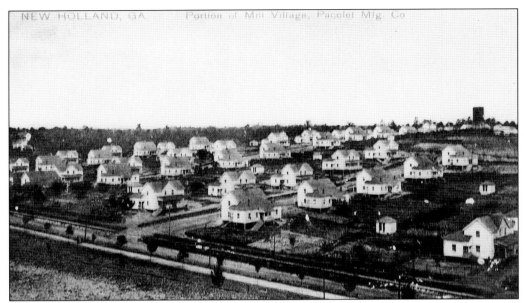

THE COMING OF THE COTTON MILLS. Cotton Mills brought the industrial age to Gainesville at the turn of the century. Gainesville Mill and New Holland were in operation by 1901, Chicopee in 1927, and the hosiery mill, Owen Osborn, in 1933. The mill buildings were the largest structures in the area, and the accompanying mill villages caused a growth spurt in the town. They also provided a new source of income and a new way of life for many mountain people. These images show Pacolet Mill Number 4 at New Holland and its village.

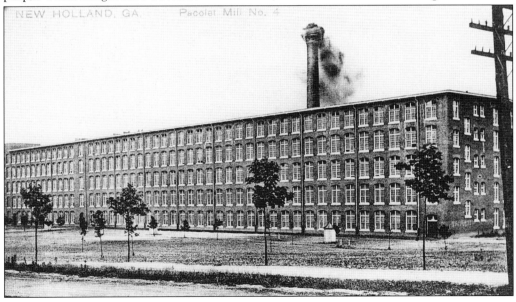

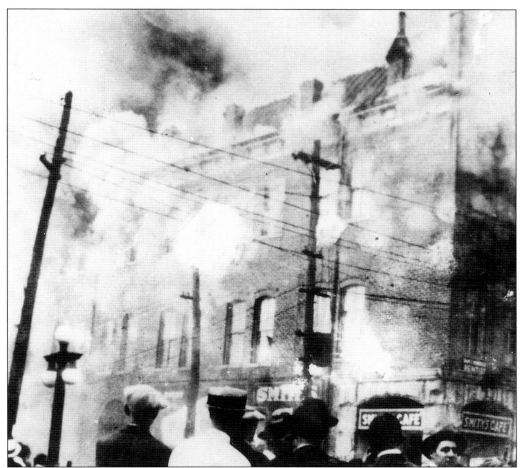

OPERA HOUSE FIRE. A huge crowd gathered and fire units came from towns as far away as Athens in May of 1925, when the ornate old Hunt Opera House burned, along with two-thirds of the rest of the block. Located at the corner of North Bradford and Washington Streets, the Opera House had been a social center for the community. It was located on the square and was easily accessible by streetcar from all of the hotels and boarding houses in town.

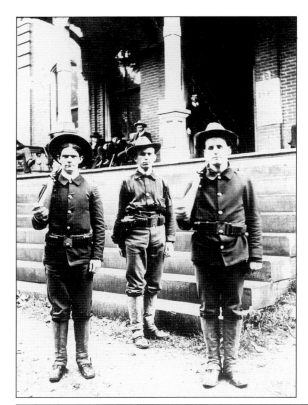

CANDLER HORSE GUARDS. Said to have been Gainesville's first military group, the Candler Horse Guards was made up of leading local citizens and was fully active by 1900. The top photo shows guards in uniform in front of the court house. The bottom photo shows the entire unit astride their horses in front of the fire department on the side of the city hall.

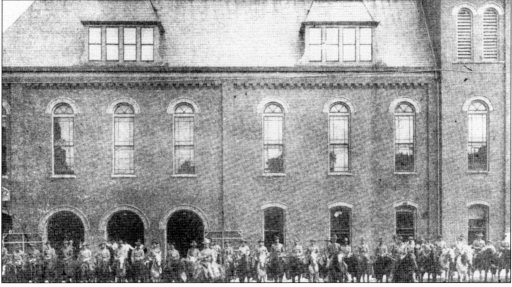

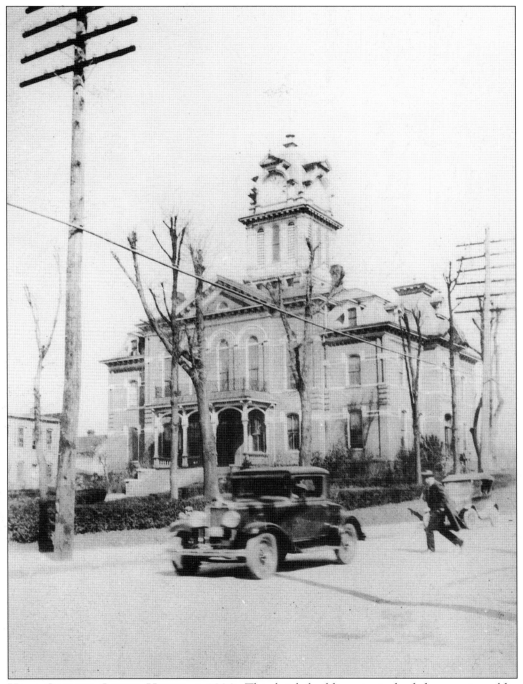

HALL COUNTY COURT HOUSE, C.1930. This brick building, typical of the ornate public buildings of the era, was built in 1883 and served as the Hall County Court House until it was destroyed by the tornado of 1936. Note the number of lines on the telephone poles.

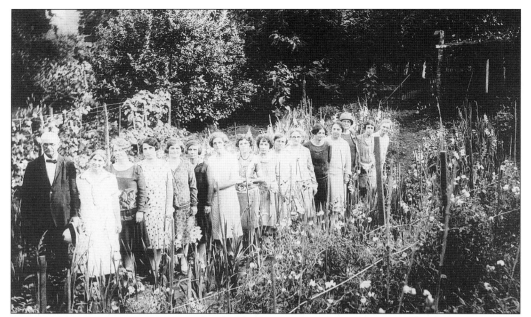

PRIOR STREET GARDEN CLUB. Said to be the first garden club in Gainesville, this group toured Mr. T.H. Robertson's garden in the 1920s. Pictured from left to right are: Mr. Robertson, Mrs. Robertson, Mrs. Pauline Hendrix, Mrs. Lambert, Mrs. Ernest Roper, Mrs. G.C. Reed, Mrs. R.M. Montgomery, Mrs. F.C. Cash, Mrs. P.A. Whatley, Mrs. Thweat Robertson, Mrs. O.J. Lilly, Mrs. W.J. Ramsey, Mrs. Will Johnson, unidentified, Mrs. Fay Brown, and Mrs. Charles Brown.

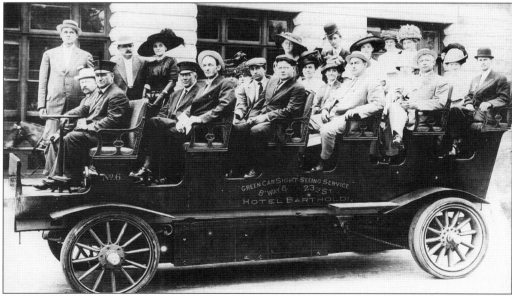

NATIONAL EDITOR TOUR. Around 1919, Albert Hardy, editor of the *Gainesville News*, brought a meeting of the National Editorial Association to Gainesville, and the group rented a tour bus to see the area. Mr. Hardy, who became national president of the group, is on the back seat at the far right.

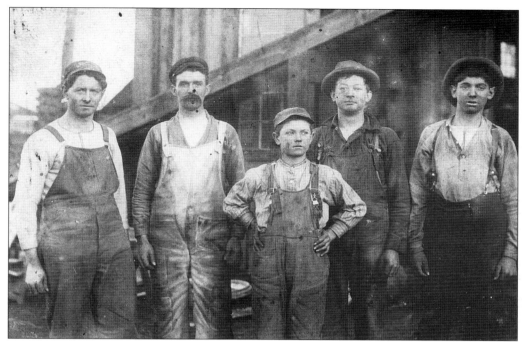

GAINESVILLE IRON WORKS. Heavy industry, in the form of an iron works, came to Gainesville at the turn of the century; the company was founded by R.I. Mealor. The worker in the center of this photo is Lelan Byrd. The others are unidentified.

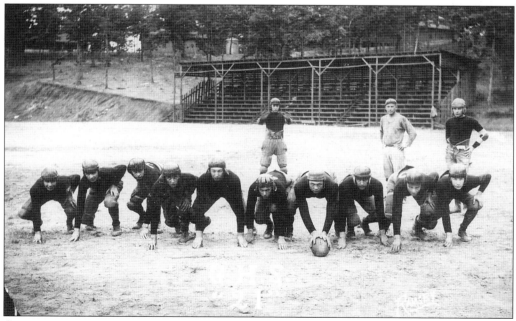

GAINESVILLE HIGH FOOTBALL, 1921. This photograph is believed to have been made at City Park by Ramsey Studio. Note the leather helmets, and the wooden stands in the background.

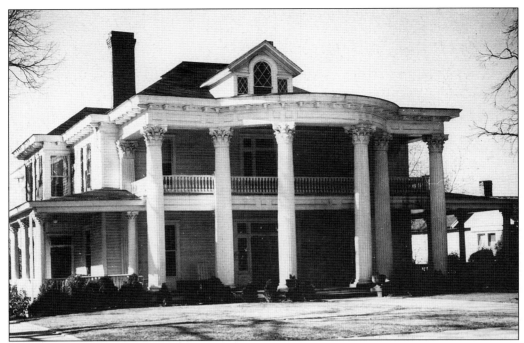

HOMES OF THE PAST. Many of Gainesville's classic old homes are gone—some due to the natural course of change and progress and others due to various disasters that have struck the city. It is estimated that almost 100 of the homes lost in the Tornado of 1936 would have been eligible for the National Register in 1999. (Above) The Oliver Carter home on Green Street was replaced by an office building for *The Times*, the local daily newspaper. (Below) "Cottage Victoria", still standing, is an excellent example of classic architectural style in Gainesville's earlier small homes. It is now owned by Brenau University.

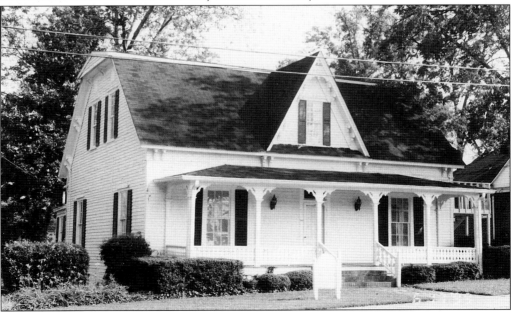

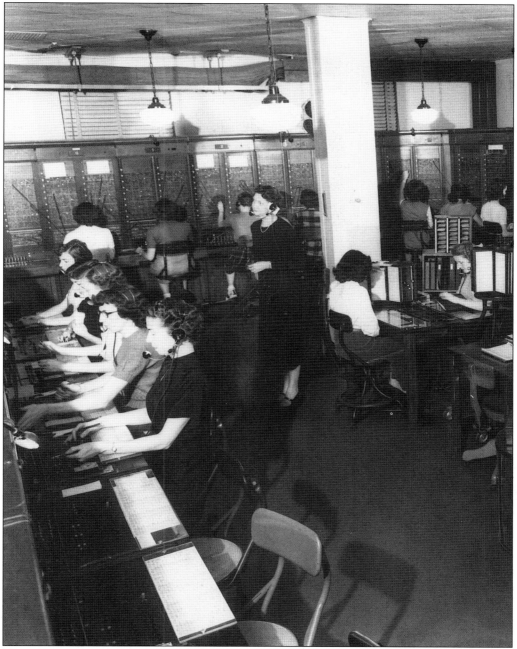

THE WAY WE TALKED. A "modern" switchboard building was first built in Gainesville in 1918, and equipment and operators were overflowing when this photograph was taken in the late 1940s. Shortly after this picture was taken, Southern Bell Telephone built a new building on East Broad Street.

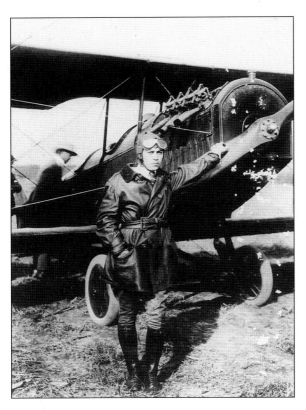

MAIL PILOT. Johnny Kytle, a pioneer pilot in the 1920s, was known as Selmon Kytle when he grew up in the Clermont area of northern Hall County. He gained fame as a mail pilot when he landed his plane on Stone Mountain—the only thing above the clouds one night—and caught a ride to deliver his cargo to the Atlanta Post Office. He was killed flying a stunt plane in the late 1920s.

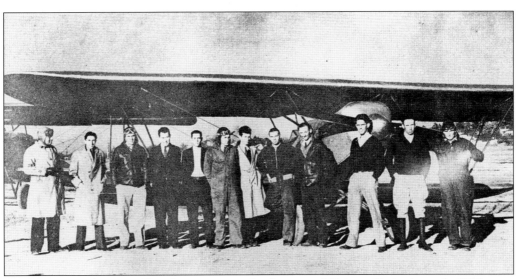

AIR PIONEERS. A group of local air pioneers who flew out of Gainesville in the early 1930s pose in front of an old Waco 10. Pictured from left to right are: Frank W. Elmore, B.B. Brannon, unidentified, Dean Parks (said to be the first man to solo here), unidentified, Everett Bell, Ernest Bell, Hugh Minor, Moseley Matthews, unidentified, Horace Seay, and unidentified.

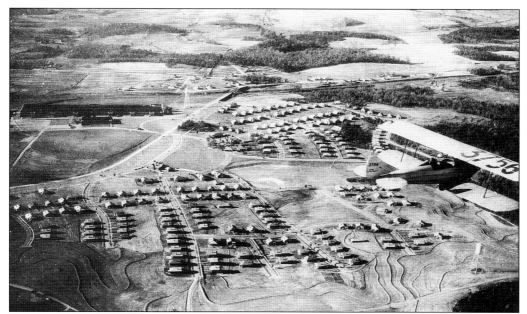

CHICOPEE, C. 1929. Seen here is a rare aerial photograph of Chicopee Village and Mill shortly after they were constructed in the late 1920s. Chicopee Village was considered a model mill village with brick homes, indoor plumbing, underground electrical wiring, and manicured landscaping. Note the airplane.

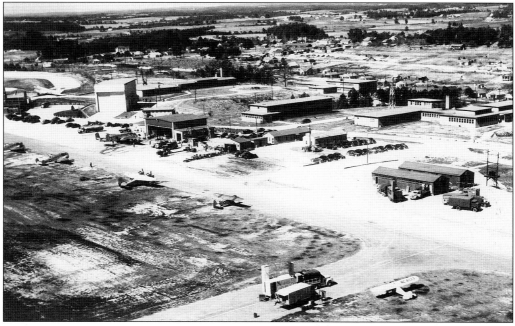

GAINESVILLE AIRPORT. Gainesville was a leader in pioneering flight in Northeast Georgia shortly after World War I, and its airport was a training station for the U.S. Navy in World War II. Development of the present airport started about 1926. Pictured above is the Gainesville Municipal Airport before it was named the Lee Gilmer Airport for another air pioneer.

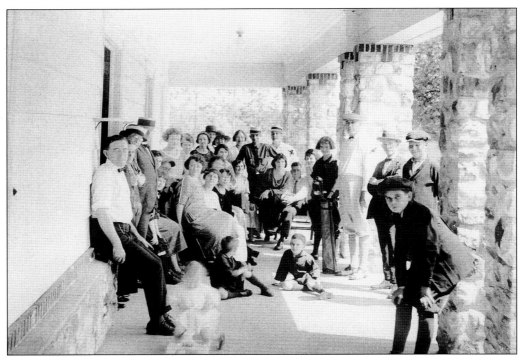

COMPANY OUTING. It was in the 1920s that employees from Newman-Frierson-McEver gathered for a company outing at the Chattahoochee Country Club. This country club disbanded and the building was remodeled and became Post 7 of The American Legion.

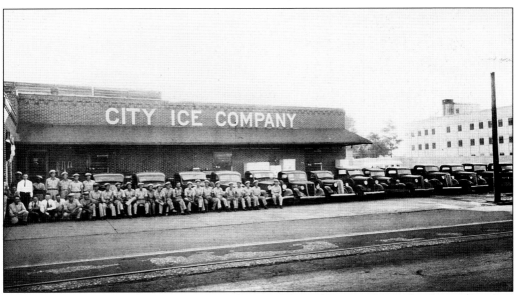

HOME DELIVERY. During the 1930s, most homes did not have mechanical refrigerators; they had ice boxes, and block ice was delivered to them on a regular basis. City Ice Company started in 1929 on Main Street. This photo was taken *c.*1938.

SEGREGATED MOVIE THEATERS. For the first two-thirds of the 20th century, public facilities such as movie theaters and restaurants were segregated. The Roxy (above), located on Athens Street, was a popular gathering place for Gainesville's black citizens. Difficult to convert for other uses because of its long, sloping floors, it was eventually torn down. The Royal (below) opened in 1930 to white patrons, early in the period when "moving pictures" were sweeping America. It became even more popular during the hot days of summer when the theater installed an air cooling system in the late 1930's. Drive-in theaters and then television gave the Royal strong competition, and it closed in 1979.

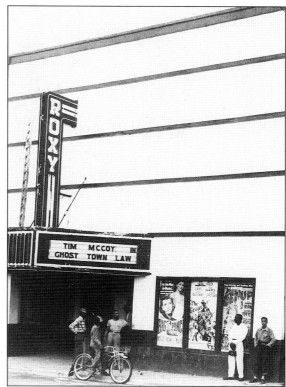

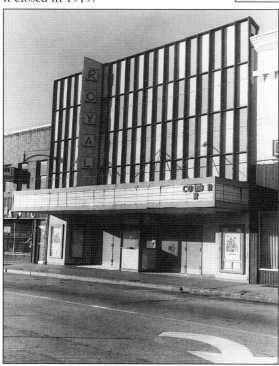

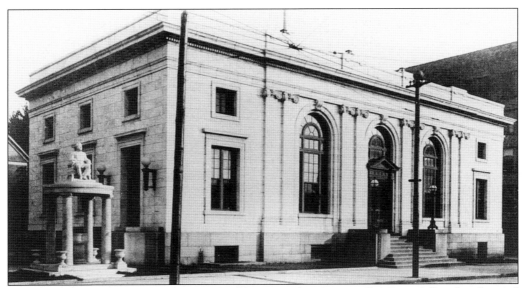

POST OFFICE. Completed in 1910, this building served as Gainesville's Post Office. It is located at the corner of Washington and Green Streets, and is now a part of the federal building. The statue at left is of Col. C.C. Sanders, a Confederate Colonel and leading local citizen. Although the building remained standing, the statue was destroyed in the tornado of 1936.

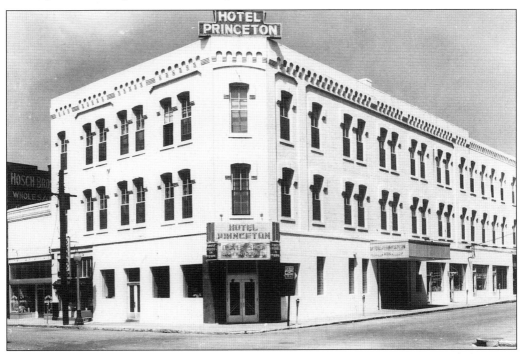

HOTEL PRINCETON. Built in 1887 as the Hudson House, this hotel was a survivor of the grand days when Gainesville was the "Great Health Resort of the South." It was located at the corner of Main and Washington, on the square. It had been remodeled before this c.1950 photo and was torn down in 1959.

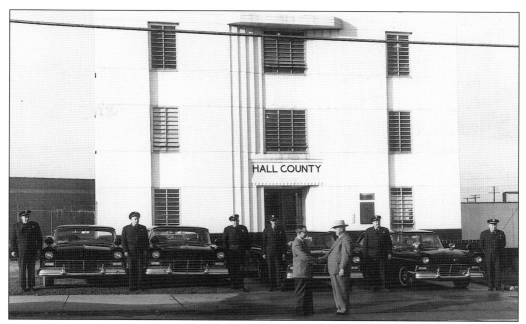

HALL COUNTY JAIL. Members of the Hall County Sheriff's Department pose in front of the jail in the early 1950s. A new jail was built, and the solid concrete hull of the building, designed to keep any prisoner from escaping, was still standing at the end of the century—an empty and unused eyesore in the center of town.

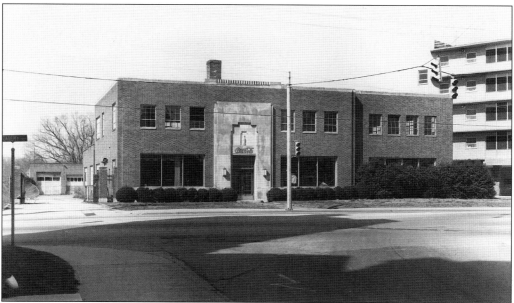

COCA-COLA. For the past 100 years, ice-cold Coca-Cola has been an integral part of Gainesville. This plant, located on Green Street across from the old methodist church, was occupied just before World War II, and served until 1968. Before the century was over, a Hall County native, Doug Ivester, became President of Coca-Cola worldwide, headquartered in Atlanta.

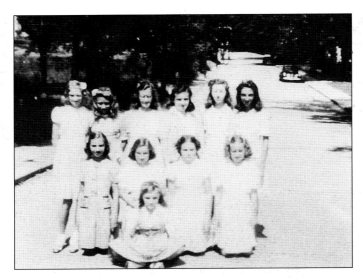

BIRTHDAY GATHERING. Early in the 1940s, these girls posed on Rice Street (now Forrest Avenue) during a birthday party. Pictured from left to right are: (in front) Joanne Moore; (front row) Joan Fuller, Mary Jo Porter, Betty Ann Meyer, and Jo Ann Terry; (back row) Frances Strong, Jane Richardson, Nellie Thompson, Wilene Jones, unidentified, and Betty Kenyon.

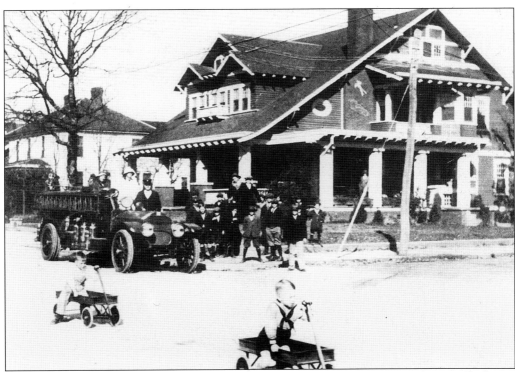

THE GOOD OLD DAYS. Gainesville once was a quiet little town in which the people knew police officers by name, the fire truck—while on its daily practice run—stopped to let pretty ladies climb aboard, and little boys raced the ladder truck while pumping their Red Flyer wagons. This house still stands on Boulevard at Park Street.

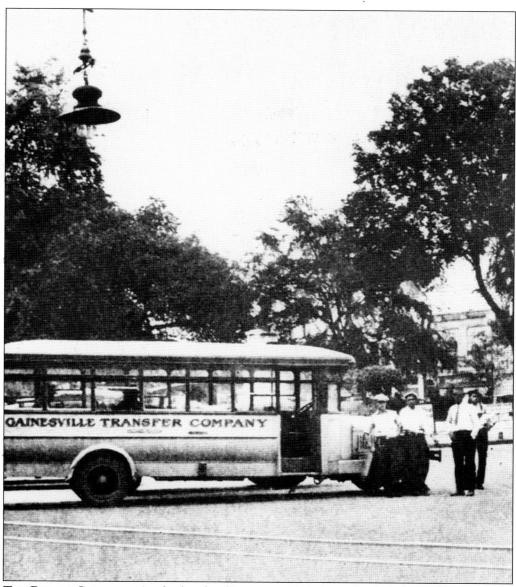

THE BUS TO CHICOPEE. A suburban bus line ran regularly between the Gainesville square and Chicopee, the mill and village three miles South of town. This photo was made *c.*1930.

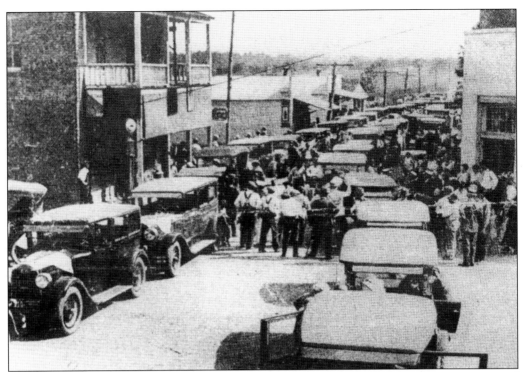

TOURIST JAM IN CLERMONT. City folks have always enjoyed touring the mountains of Northeast Georgia, especially as the leaves turn in the fall. During the 1920s and 30s, villages between Atlanta and the mountains enticed tourists to visit their towns by offering free cookies and cold cider. This created traffic jams, like the one pictured in Clermont in the late 1920s.

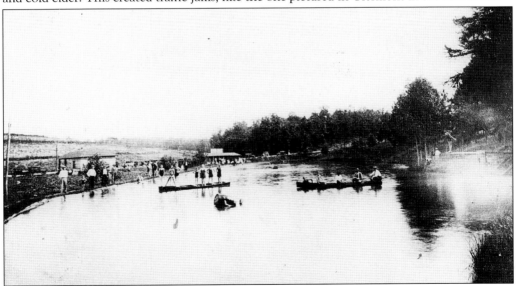

WAYNE'S LAKE, C.1925. Near Flowery Branch, Wayne's Lake was one of the first swimming and recreational businesses outside Gainesville. Visitors could picnic, swim, dive, rent boats, and meet friends, old and new, at this facility in South Hall County.

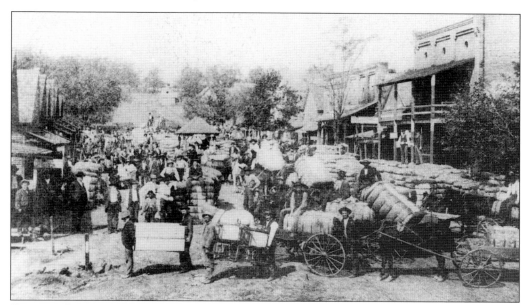

COTTON COMES TO FLOWERY BRANCH. In late fall, farmers picked their cotton, took it to a nearby gin, and hauled the bales to nearby towns where they sold them to cotton merchants. This is the main street of Flowery Branch, probably about 1910. "Cotton was King" in Hall County until the 1940s.

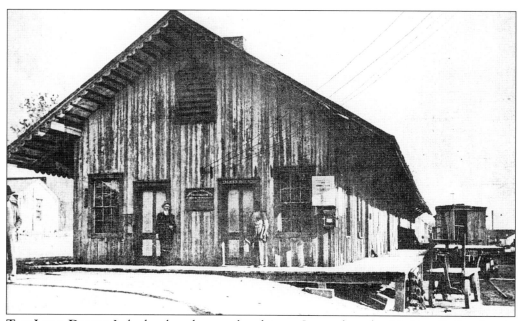

THE LULA DEPOT. Lula developed as a railroad town. Located on the Air Line Railroad main line, which connected Charlotte and Atlanta, it also had a railroad connection to the east toward Athens. This depot burned.

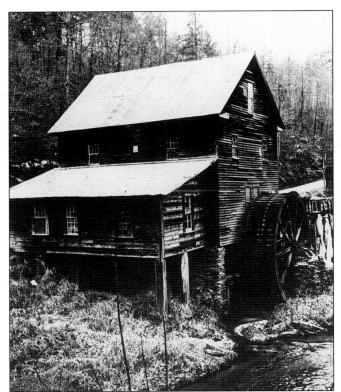

TANNER'S MILL. Gristmills, an important part of rural economic life during the 1800s, were still active in the early 1900s. Tanner's Mill had been built some time prior to 1820. Water ground meal was considered an advantage in making good cornbread, and some people say it still is.

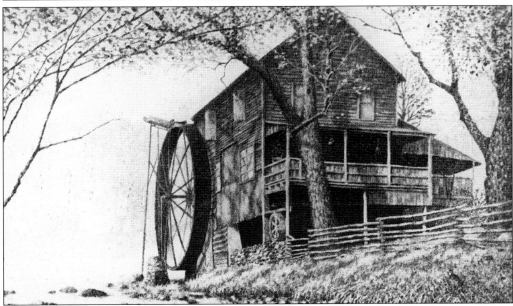

HEALAN'S MILL. Powered by a large iron water wheel, Healan's Mill was built prior to the Civil War. Local farmers took their grain to these mills to be ground into meal or flour, some for their own use and some for sale. Though the buildings remained, the mills had mostly ceased to be active by the middle of the century.

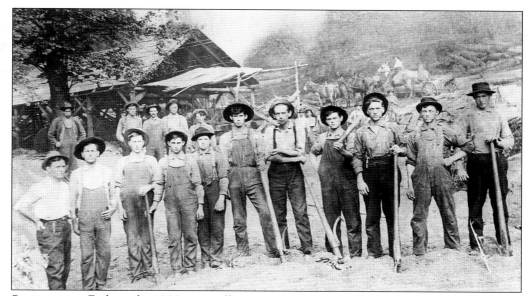

SAWMILLING. Early in the 1900s, sawmilling was a huge business in the mountains of Northeast Georgia. Gainesville, Lula, and Cornelia became major loading points where lumber was transferred from local railroads to the trunk lines and shipped all over the United States.

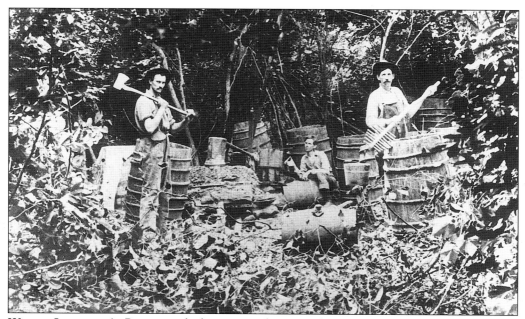

WHITE LIGHTNIN'. Brewing whiskey was a long-standing tradition in the mountains of Northeast Georgia, but moonshining got an unexpected boost in the 1920s and 30s when the U.S. Constitution was amended to make whiskey-making illegal. Gainesville was known as a major supply point for sugar, glass jars, and high-speed cars.

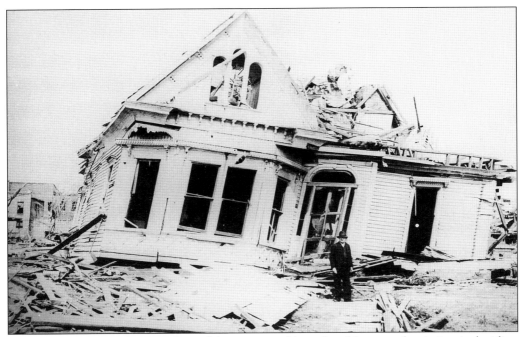

SAVE IT OR TEAR IT DOWN. One of the major problems faced by tornado victims is deciding whether to save a home or tear it down and start over. Some two-story homes ended up as one-story cottages. This image is from the Tornado of 1936.

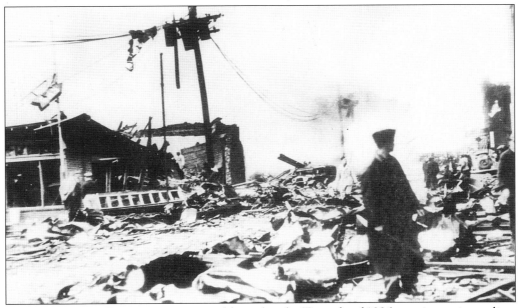

SMOKE AND FIRE. Fires were a major problem after the Tornado of 1936, causing an immediate and frantic search for trapped people.

Two
TORNADOES

April 6, 1936, provided Gainesville with its single most newsworthy day of the 20th century . . . and the news was not good. On that day, a tornado, actually three tornadoes, swept through the heart of town at 8:27 in the morning. It was the most devastating American tornado up until that time. The U.S. Weather Bureau reported 203 people killed and 934 injured. The Red Cross said 139 homes were totally destroyed, 198 seriously damaged, and 2,094 families affected. The devastated area was eight miles long, and varied in width from one-half to one mile. It took only three minutes for the storm to complete its trip.

The Tornado of 1936 was neither Gainesville's first tornado nor its last. A tornado that hit in 1903 took almost 100 lives, centering its fury on the then new Gainesville Mill and its village. Although the loss of life never again reached these proportions, the Hall County area has continued to be plagued by highly destructive tornadoes from time to time.

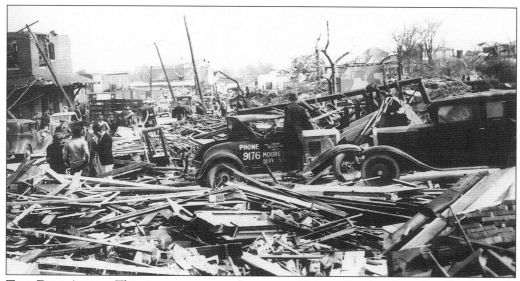

THE DAY AFTER. This image captures downtown Gainesville the day after the Tornado of 1936.

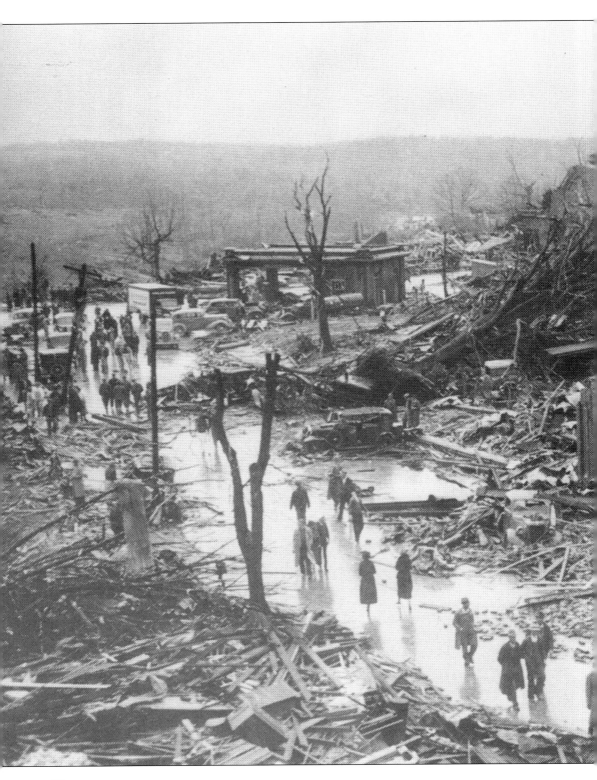

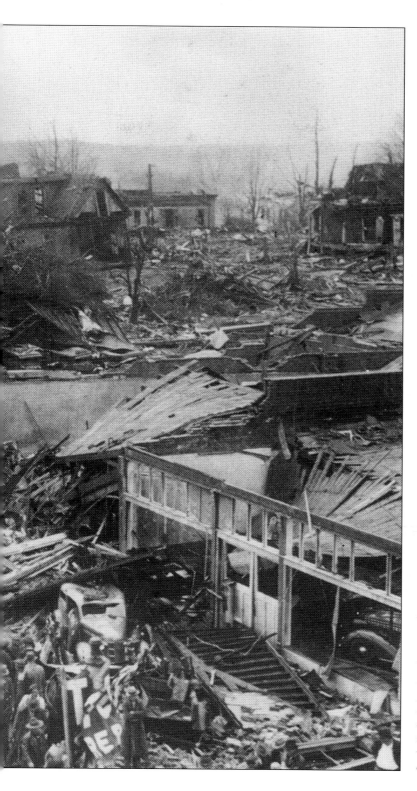

TORNADO OF 1936. Looking down Spring Street from the Dixie Hunt Hotel, two tornadoes converged at this point in the business district, only one block from the main square. The heaviest loss of life occurred in this general area, the result of flying debris, collapsed buildings, and finally a fire in which a number of citizens were trapped.

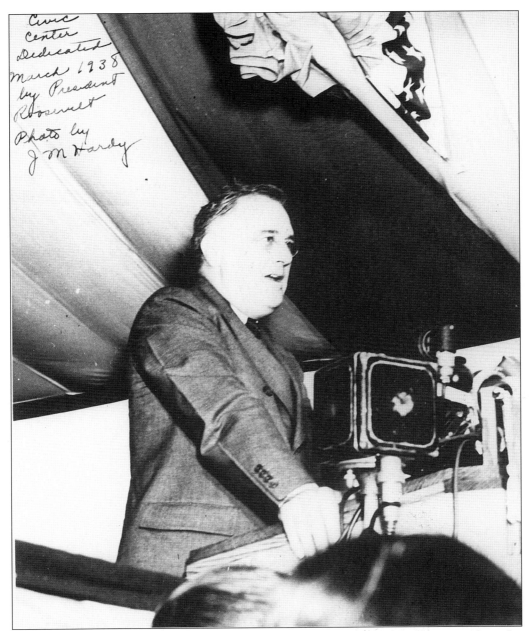

Civic
Center
Dedicated
March 1938
by President
Roosevelt

Photo by
J M Hardy

FDR VISITS. President Franklin D. Roosevelt was in Warm Springs, Georgia, when the tornado struck in 1936. A few days later, on his return trip to Washington, he stopped his train and made an appearance in Gainesville, pledging the help of the federal government. This photograph was made in March 1938, when he returned to dedicate the civic building, pledge his continued support, and commend the city on its courage in reconstruction.

40

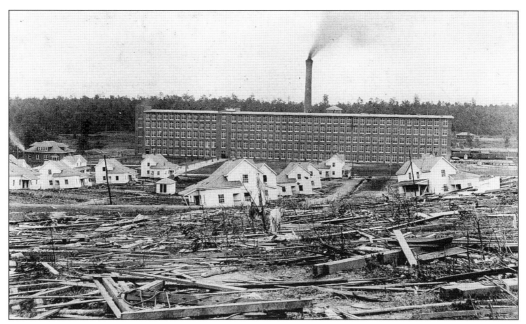

TORNADO OF 1903. The Tornado of 1903 struck primarily in the Gainesville Mill area. (Above) Houses of the village were either blown apart or pushed off their foundations and down the hill. (Below) The top floors were blown off the Gainesville Cotton Mill, the scene of most of the deaths. Almost 100 people died in the tragedy. Note the people standing on top of the mill.

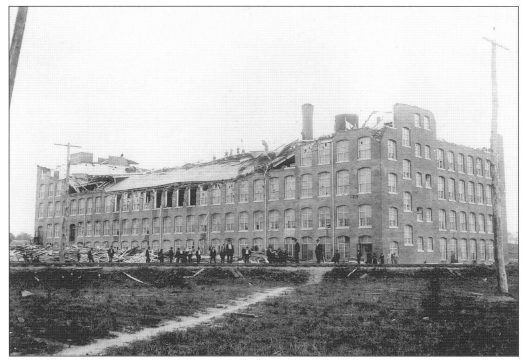

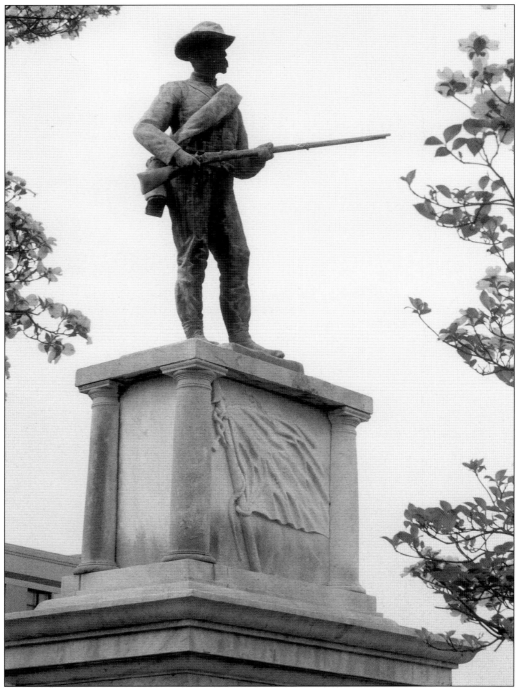

"Old Joe." This monument commemorating those who fought for the Confederacy, dubbed "Old Joe" by locals, was erected by the Longstreet Chapter of the United Daughters of the Confederacy. It was unveiled in June 1909.

Three

THE GAINESVILLE SQUARE

During the past century, no spot in this county has been more indicative of the character of Gainesville and Hall County than the downtown square. It was the center of business, banking, government, and justice.

But the square was more than that. It was where farmers brought their wagons on Saturday; where itinerant preachers thundered their messages; where town women bought farm-fresh produce; where farm women bought print dresses; where politicians spoke; and where boys and girls met and flirted.

Early in the century, to go to the square was to go downtown, and downtown was where the action was.

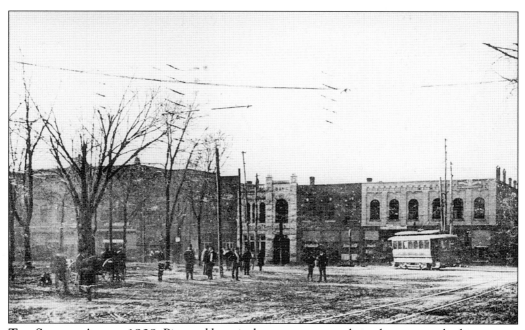

THE SQUARE ABOUT 1908. Pictured here is the square very early in the century, looking across toward the Arlington Hotel (later the Dixie Hunt Hotel, then Hunt Tower). Note the dirt streets. The bare trees and closed sides of the streetcar indicate that it is mid-winter.

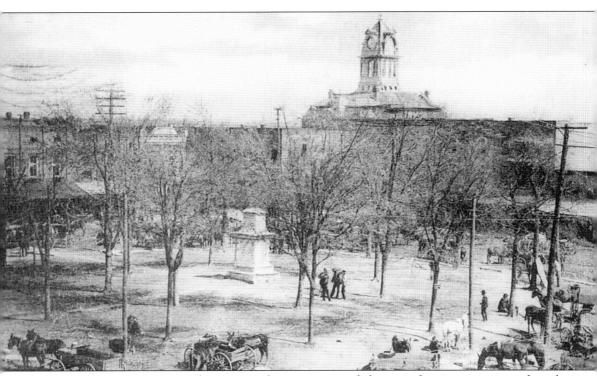

THE SQUARE, C.1915. Looking across the square toward the court house, you get an idea of how that building dominated the area. "Old Joe" is in place. Note the mules and wagons, and the absence of cars.

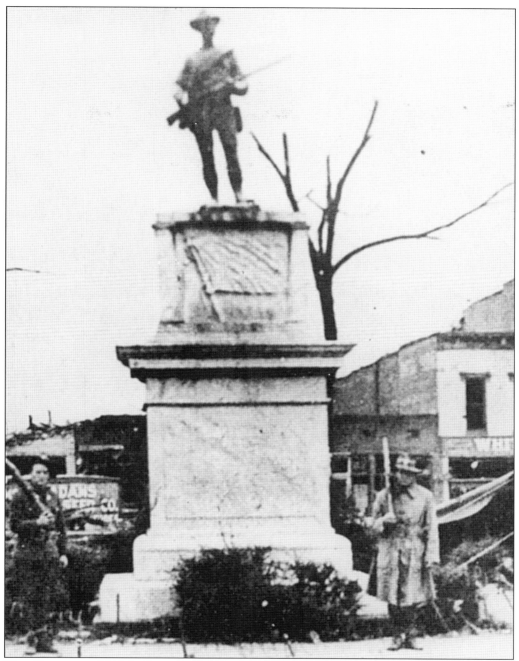

THE TORNADO. "Old Joe" survived the Tornado of 1936, but the trees around him did not. Troops from the Georgia National Guard set up tents to feed workers, coordinated the cleanup efforts, and guarded against looting and vandalism (which was minimal). Note the soldiers standing guard with rifles, and the Adams Transfer truck in the background.

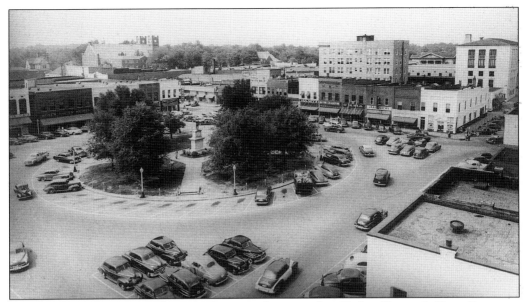

THE CIRCLED SQUARE. With a round center, the square handled traffic much like a European "rotary." This view was from the top of the Dixie Hunt Hotel, c.1950, with a good view of the Jackson Building and, in the distance, the First Methodist Church. Note the parking spaces available where parking meters are located on the circle.

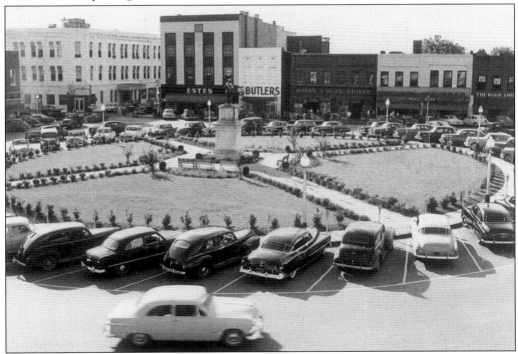

NEW LANDSCAPING. By 1955, the trees had been removed to open up the view on the square, but the circle remained. In this era teenagers cruised the square, and it was a young peoples' gathering place. This picture was probably taken from the top of Belks on the square.

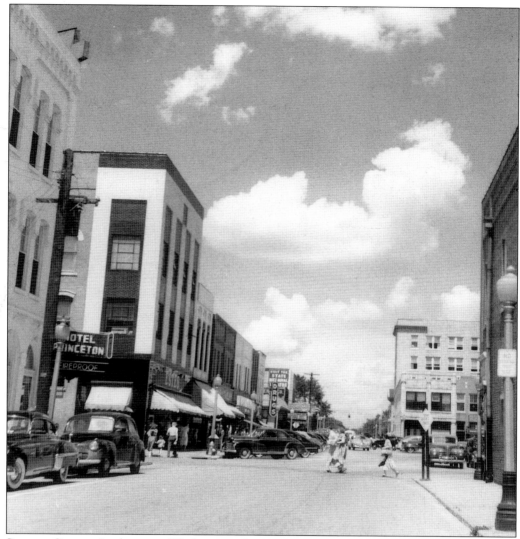

STREET SCENE. Looking up Washington Street and across the square toward the Jackson Building, the Estes building is seen on the left. It burned and was replaced with a two-story building. Note the street lamp design at the right of the picture.

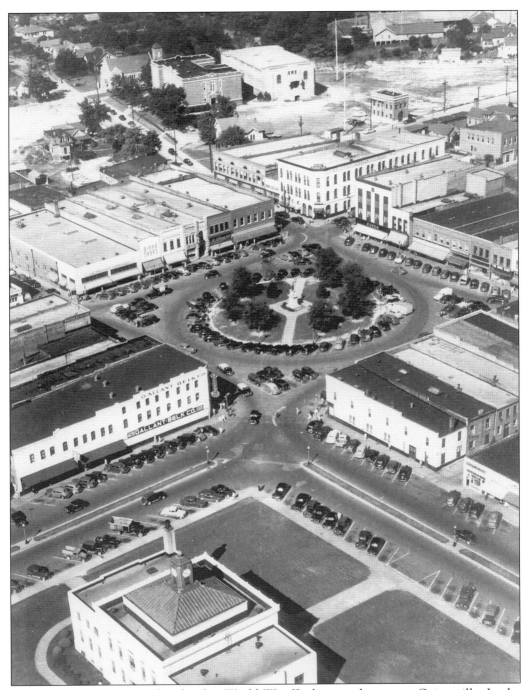

SQUARE FROM THE AIR. Shortly after World War II, this was downtown Gainesville. In the front is the court house before the addition. In the rear is Gainesville High and the gym of 1936. The block at left, showing Gallant Belk, was torn out for parking. Later, the center of the square was squared to keep drivers from going round and round. Temporary landscaping was done during the Olympics, then taken out.

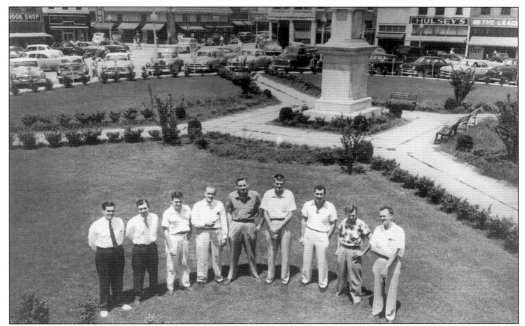

THE JAYCEES GET INVOLVED. During 1951–52, the Gainesville Jaycees provided landscaping and walks for the remodeled square. The committee members are pictured from left to right: John Jacobs, unidentified, Gordon Sawyer, Charles Frierson, Wayne Staton, Perrin Reynolds, Ed Nivens, Buddy Hughs, and Spec Towson.

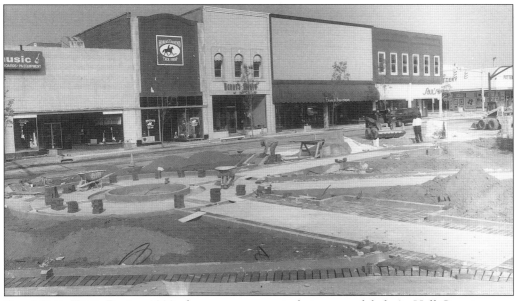

ONE MORE TIME. During 1999, the square was again being remodeled. As Hall County grew, and with the advent of shopping malls and other businesses off the square, the central business area declined and was seeking new life through a Main Street revitalization program.

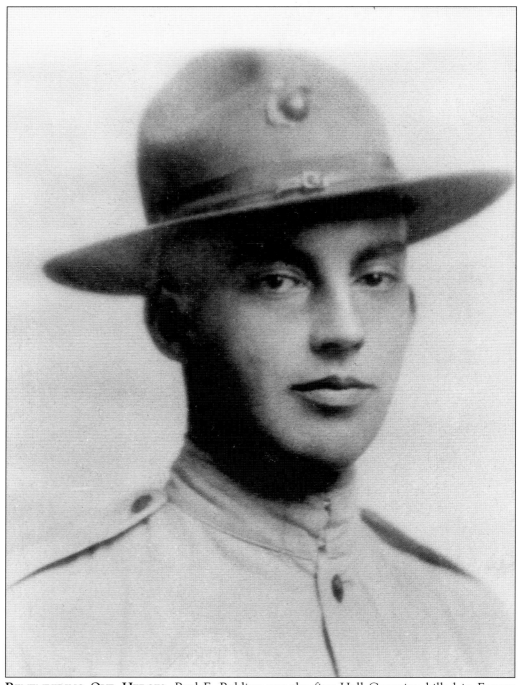

REMEMBERING OUR HEROES. Paul E. Bolding was the first Hall Countian killed in Europe during World War I. Gainesville's Post 7, The American Legion, carries his name.

Four
A TIME OF PATRIOTISM

It is a historic fact that the mountain people of Northeast Georgia have always been patriots, and the 20th century brought no exception. As we look back over the past 100 years we remember a time when school children recited the Pledge of Allegiance; when parades and ceremonies celebrated victories and honored those who served; and when young men and women volunteered for service.

For the last four decades of the century, one of the annual community highlights has been the Fourth of July fireworks over Lake Lanier, sponsored by the Paul E. Bolding Post 7 of the American Legion and Riverside Military Academy. In 1999, an estimated 9,000 people came by land and water to share in the patriotic event.

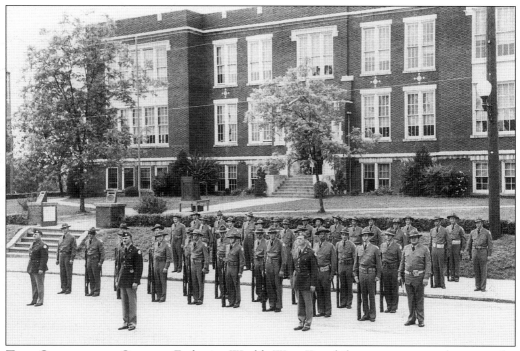

THE GAINESVILLE GUARD. Early in World War II, while young men who met the qualifications were entering the U.S. military, a home guard was established. For the most part it consisted of leading citizens who were either too old or too young for active military duty. Many of the younger members went on to active service. Pictured here, Gainesville's Company A, 2nd Battalion of the Georgia State Guard, under the command of Capt. J. Larry Kleckley, stand at attention in front of Gainesville High School, c.1943.

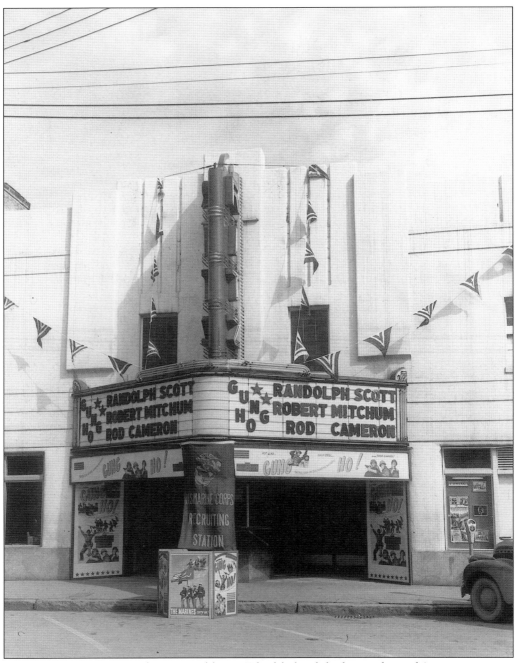

GUNG HO! Many movies during World War II highlighted the heroic feats of American service men, as did *Gung Ho!*, playing at the Ritz Theater on Bradford Street in downtown Gainesville. The banner hanging in front of the theater points out that, for this day at least, this was a Marine Corps Recruiting Station.

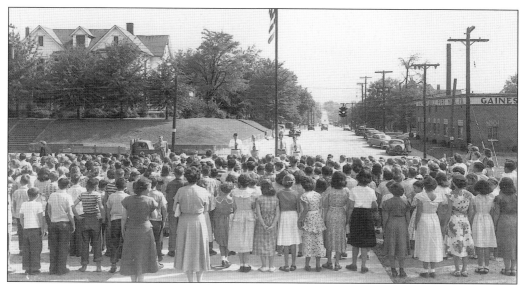

FLAG PRESENTATION AT MAIN STREET SCHOOL. Veterans groups presented flags to local schools. This ceremony was at Main Street School, which was later torn down. It is now the location of the Hall County Jail.

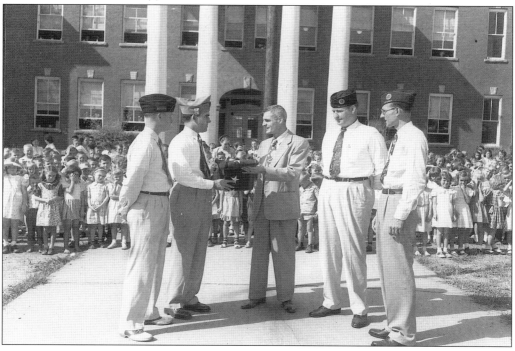

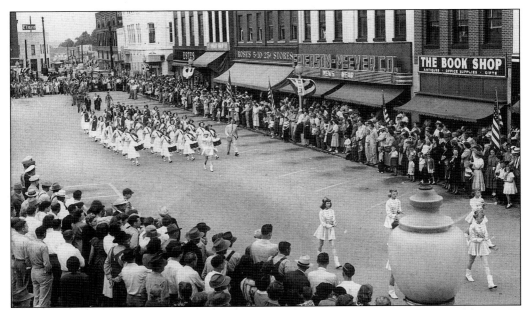

MEMORIAL DAY PARADE. Patriotic parades continued for many years after World War II, celebrating Memorial Day, Armed Forces Day, the Fourth of July, and Labor Day. They included both military and civilian units. Note the crowd on the Gainesville square.

THE AMERICAN LEGION. Post 7 of the American Legion was formed in Gainesville following World War I. This building, located at the end of Riverside Drive, became the post's home and center of veterans' activities following World War II. It later burned and was replaced by a similar building.

VE-DAY PARADE. During World War II, the fighting ended in Europe before it did in the Pacific. Ceremonies were a combination of celebration for the end of fighting against the Germans, and a "buildup" as we got ready to end our war against the Japanese. This group, shown here marching down Spring Street, participated in a Victory in Europe Day celebration in Gainesville. Note that this was a Women's Navy Unit (WAVES).

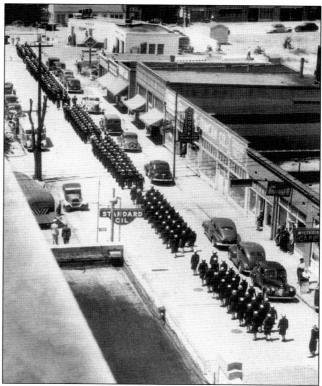

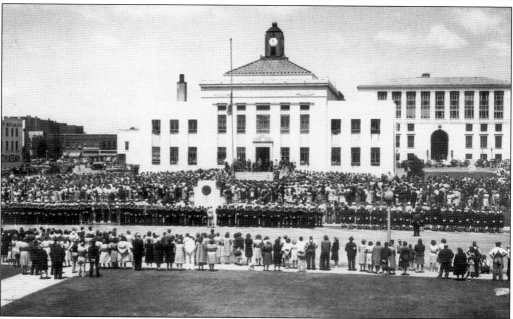

VICTORY IN EUROPE. In May 1945, crowds of local citizens joined with military service groups in Roosevelt Square to hear speeches about victory in Europe and the job yet to be done in the Pacific. Soon after, the dropping of atomic bombs ended the war against Japan.

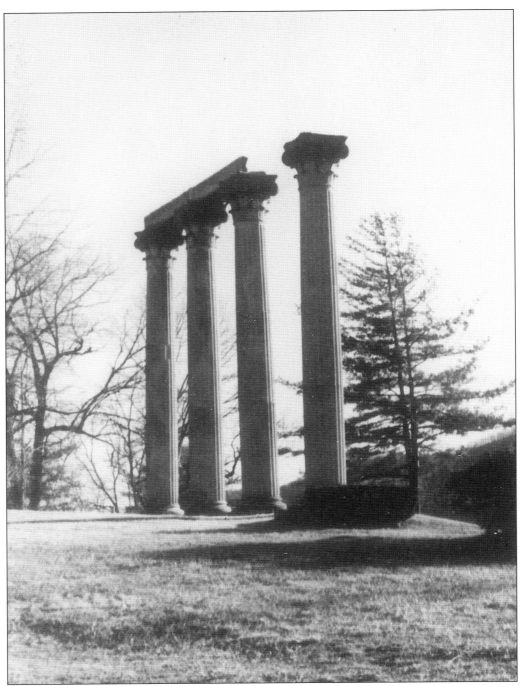

MOUNTAIN MYSTERY. Hikers coming back from the North Georgia mountains have been known to report seeing "mysterious" columns, as if they had just discovered some Roman ruins. These columns graced the front of the First Baptist Church of Gainesville until the building burned in 1960. Warren Castle purchased them and they were moved to this remote spot in the mountains, north of Dillard, where they mark the line between Georgia and North Carolina.

Five

OUR RELIGION, OUR VALUES

Almost every church in Gainesville that existed in 1900 constructed a new building during the past century, and some have built two. As the county has grown, churches have grown, and many new churches have been formed.

This is not an attempt to record the history of religion in Hall County, for that would be a book in itself. It is, instead, an effort to provide a glimpse of what we looked like in an earlier time and as the century progressed, as well as to illustrate some of the activities born out of the community's collective values.

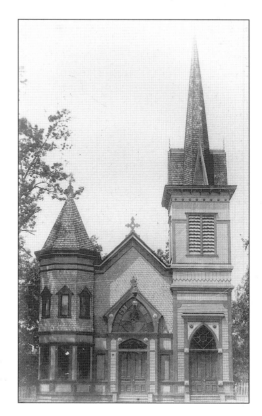

DESTROYED BY THE STORM. This ornate building served two churches during the 20th century: First Presbyterian until about 1907, and then St. Paul Methodist. It was obliterated by the tornado of 1936. It was located at the end of Spring Street, one block from the square.

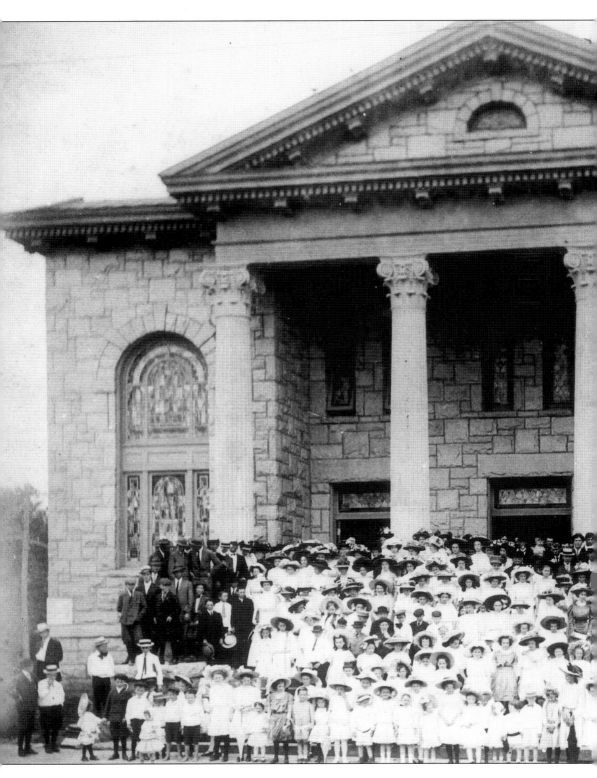

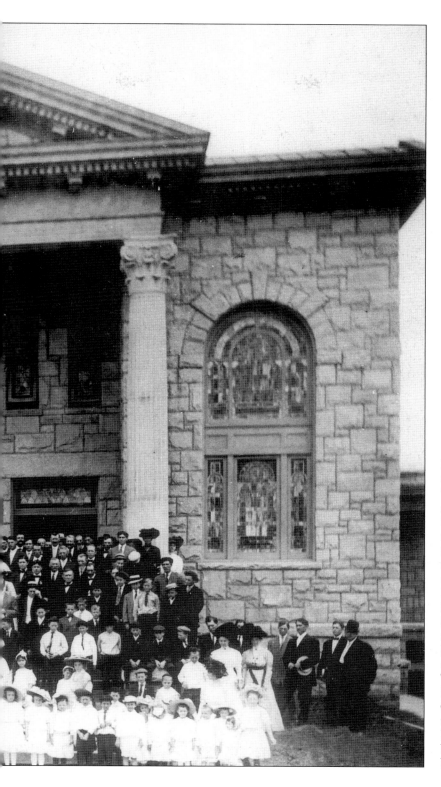

FIRST BAPTIST CHURCH. This photograph of the First Baptist Church and its congregation was taken about the time the church was dedicated in 1909. The building burned in 1960, and a new church was built further out on Green Street. This building was located across Green Street from the Federal Building, replaced by a RegionsBank building.

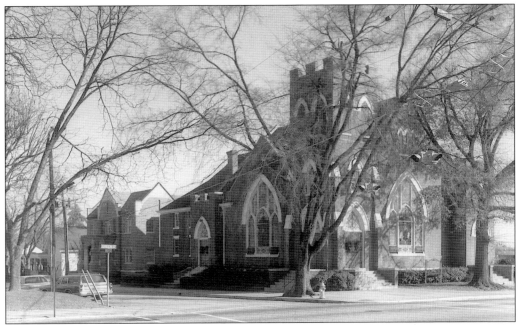

FIRST PRESBYTERIAN CHURCH ON GREEN STREET. Completed in 1907, the church added a Sunday school building in the 1950s. A new church was built on Enota Drive in 1975. This building was located on the block where SunTrust Bank now stands.

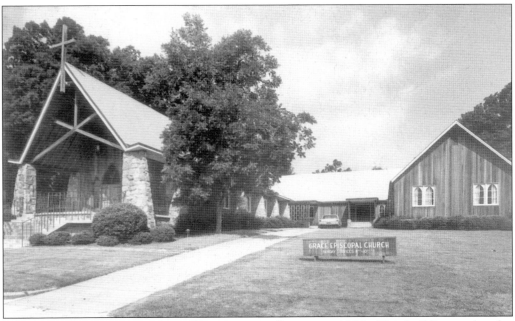

GRACE EPISCOPAL CHURCH ON WASHINGTON STREET, C.1960. This building replaced a church built about 1937, which was located at the corner of West College and South Bradford. A new sanctuary has been built at the corner of Washington and Boulevard.

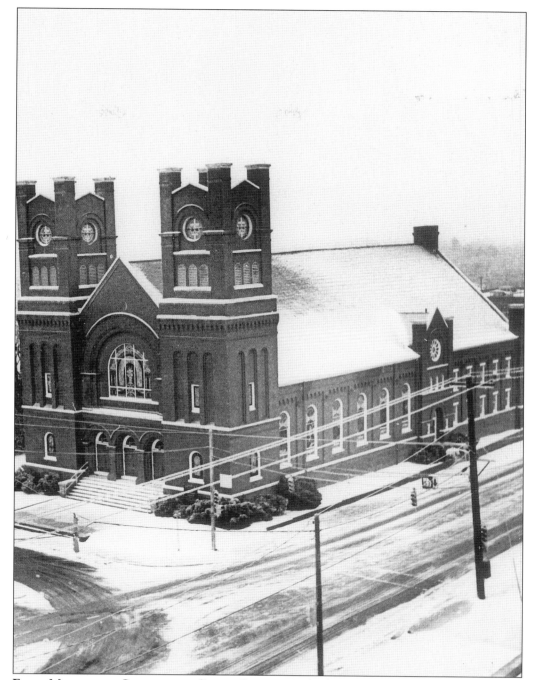

FIRST METHODIST CHURCH ON GREEN STREET. Built about 1908, the church is seen here following a snowfall in 1979. The church moved to a new building located on Thompson Bridge Road, across the river. This building still stood at the end of the century.

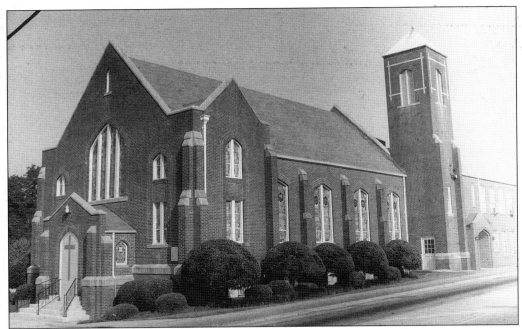

St. Paul Methodist Church, on Washington Street.

St. John Baptist Church, on E.E. Butler Boulevard.

ANTIOCH BAPTIST CHURCH, LOCATED
ON MILL STREET.

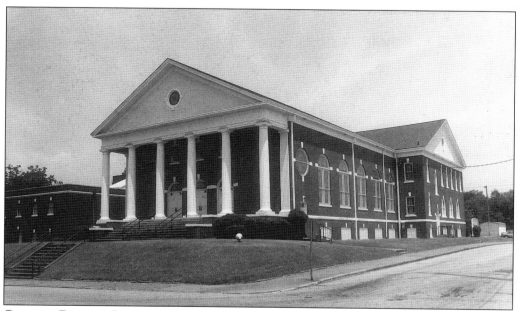

CENTRAL BAPTIST CHURCH, ON MAIN STREET, S.W.

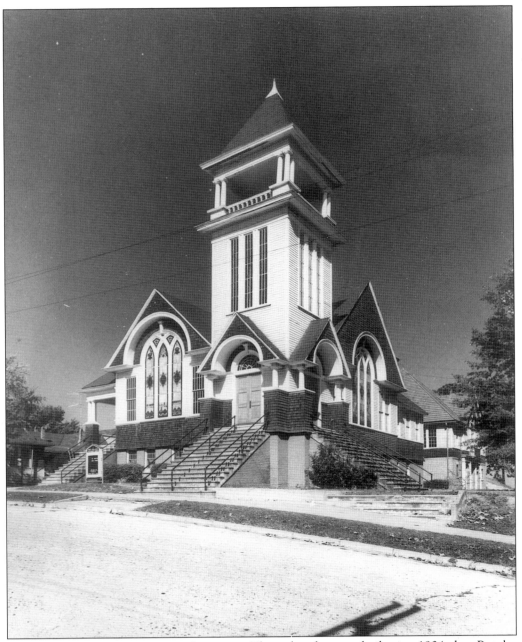

New Holland Methodist Church. This church was built in 1904 by Pacolet Manufacturing Company as part of its mill village. In the beginning, Methodists and Baptists used the building on alternate Sundays. Considered a classic example of the architecture of the time, the building is still in use.

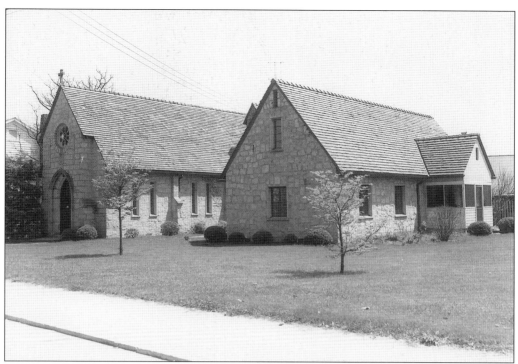

ST. MICHAEL'S CATHOLIC CHURCH.
Located on Spring Street near Brenau
College, this building is used for
offices. A new church has been built
on Enota Avenue.

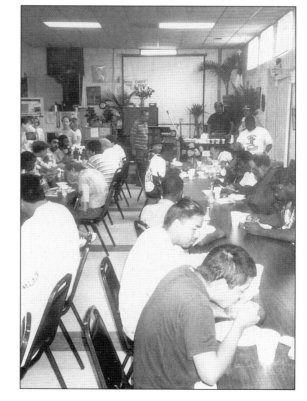

GOOD NEWS AT NOON. A Christian
ministry supported by local churches
and individuals, Good News serves hot
meals daily to those in need, and
provides shelter for the homeless,
as well as other services for the
community. A volunteer clinic is
an adjunct part of this mission.

EAGLE RANCH. Founded in the early 1980s, Eagle Ranch provides a Christian home for boys who have been abused, neglected, or need a stronger family support system. Eagle Ranch is, at the end of the century, also establishing a facility for girls. Seen here are founder Eddie Staub and two boys.

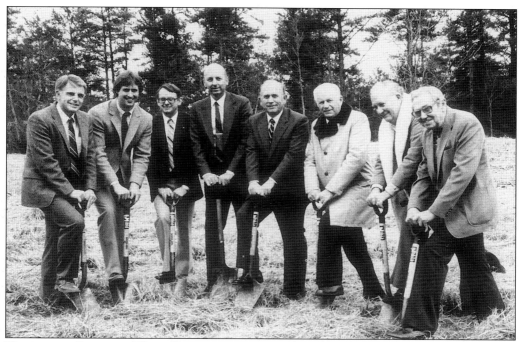

KIWANIANS SUPPORT. These Kiwanians participated in the groundbreaking for Eagle Ranch after the local club donated $20,000 toward the project. Pictured from left to right are: Austin Edmondson, Eddie Staub, Nat Hancock, Russ Moehlich, P. Martin Ellard, Curt Severson, Hal Rhodes, and John Thompson.

CHRISTIAN EDUCATION CENTER. In the late 1960s, when it became apparent that religious courses would not be allowed in public schools, a group of local churches bought land and built a Christian Education Center adjacent to Gainesville High School. The program has expanded to other schools in the area, and has gained national recognition as an answer to the separation of church and state.

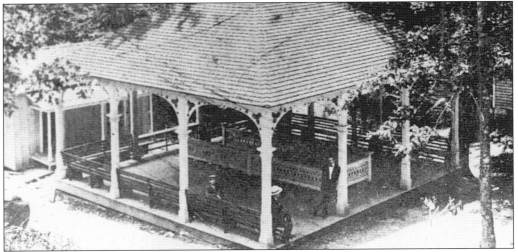

WHITE SULPHUR SPRINGS. This nationally recognized summer resort, which drew fashionable visitors from all over the world in the late 1800s, declined in popularity and burned in 1933. According to its promotional materials, its springs were "noted for marvellous cures wrought by the water in cases of rheumatism, blood poisoning, dyspepsia and other complaints."

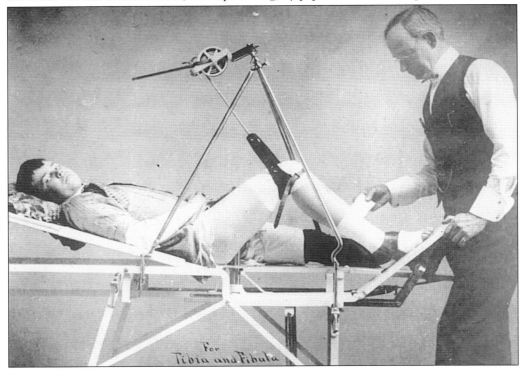

For
Tibia and Fibula

MOUNTAIN MEDICINE. Northeast Georgia has a long history of innovative doctors and effective medicine. In nearby Jefferson, Dr. Crawford Long gained worldwide attention for pioneering the use of anesthesia. Dr. James Henry Downey gained widespread recognition for Gainesville when he patented this special table which utilized suspended weights to hold bones in place while they healed.

Six

FROM HEALTH RESORT TO MEDICAL CENTER OF THE MOUNTAINS

In the 1880s, Gainesville billed itself as "The Great Health Resort of the South." People from the coastal South came here in summer to escape the "dreaded fever," which turned out to be malaria, carried by mosquitoes. But it was the mineral springs that drew most visitors. A promotional brochure for Gainesville in 1888 stated: "The medicinal waters of the vicinity of Gainesville were long used and prized by the Indians, and since the settlement of the country by the whites, they have been resorted to annually by invalids from all portions of the South." Although the appeal of the mountains remains, the allure of the Springs as medical "cure-alls" faded.

During the 20th century, Gainesville evolved to become the medical center for Northeast Georgia with two hospitals and about 300 practicing physicians. Most of this growth came after the middle of the century.

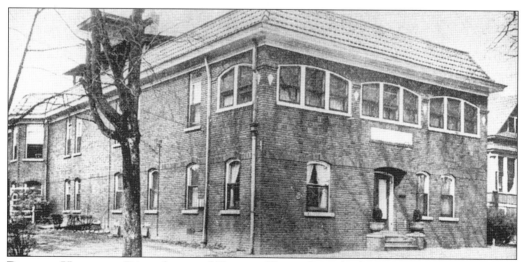

DOWNEY HOSPITAL. Privately-owned Downey Hospital was built in 1912. It may have been the first accredited hospital in Georgia, and remained the primary medical facility for the area until the Hall County Hospital was occupied in 1951. Downey Hospital was located on Sycamore Street, which was later renamed E.E. Butler Parkway for Gainesville's first black physician.

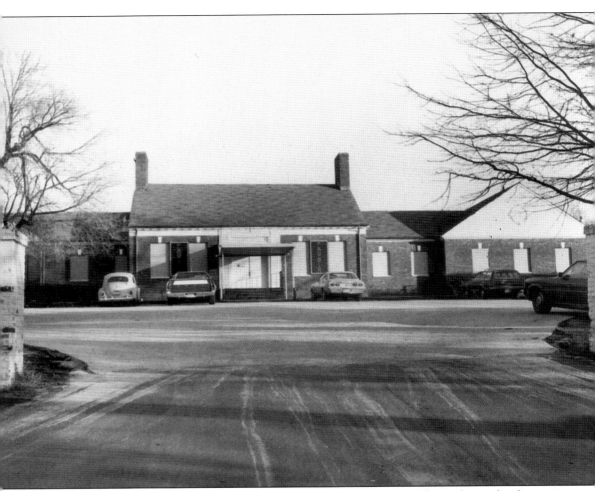

OLD HALL COUNTY HOSPITAL. Built in 1934 with government funds as a home for the poor, this building later became a private hospital for a number of years. After closing as a hospital it became a restaurant, and at the end of the century houses the area's only topless dance hall.

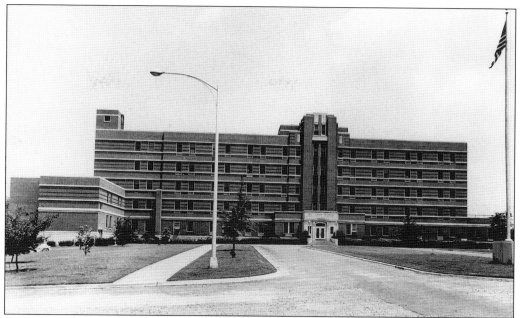

HALL COUNTY HOSPITAL. The Hall County Hospital was opened in 1951. It was located on Spring Street. The facility immediately attracted a community of physicians' offices in the area surrounding it.

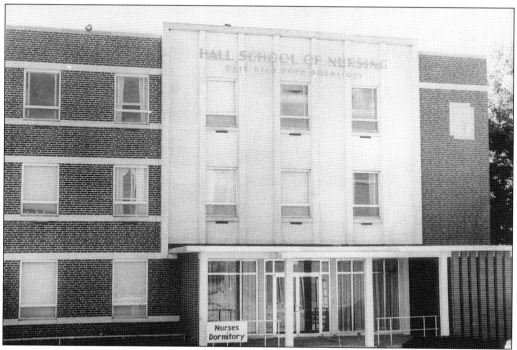

HALL SCHOOL OF NURSING. The nursing school opened in 1960 as a part of the Hall County Hospital. Located on the hospital grounds but adjacent to Brenau College, the school became a part of Brenau in 1978 and offers a BSN degree.

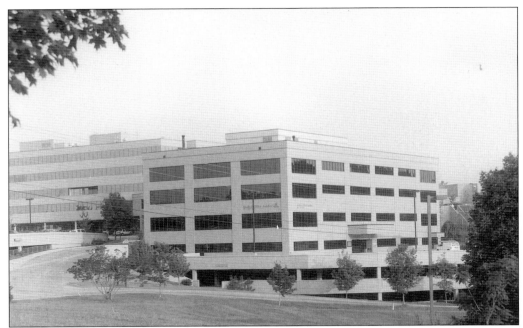

NORTHEAST GEORGIA MEDICAL CENTER. This hospital, which started as the Hall County Hospital, has grown into the largest medical complex in the area, and serves most of Northeast Georgia. It is located at 743 Spring Street in Gainesville.

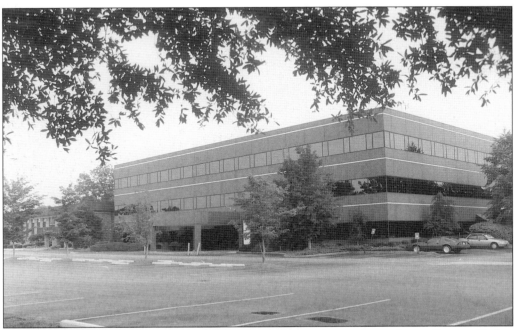

CLINICS AND PHYSICIANS' OFFICES. In addition to the two hospital complexes, Gainesville has in the past 50 years developed a wide array of clinics and offices for general practice and specialized medicine. Pictured is the Northeast Georgia Diagnostic Clinic on Broad Street.

LANIER PARK HOSPITAL. This privately owned hospital is surrounded by a medical park containing physicians' offices and other support services (see aerial photo). The main entrance to the hospital is located at 675 White Sulphur Road.

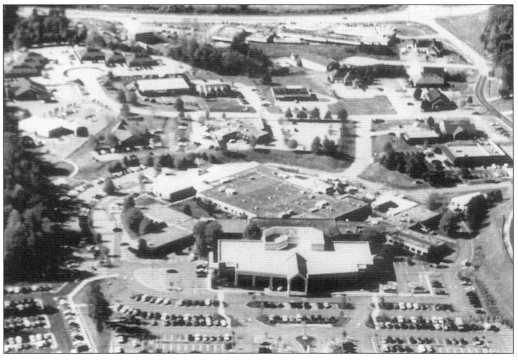

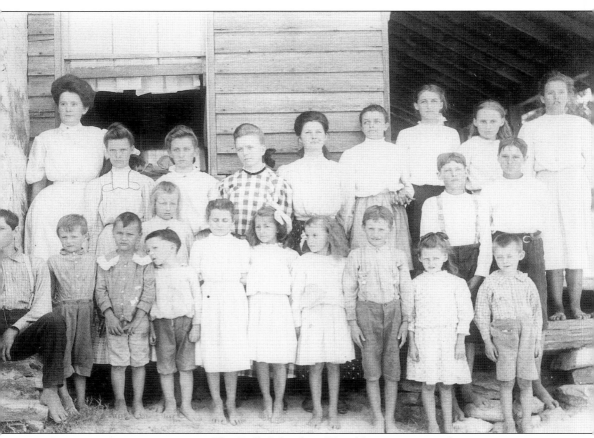

COUNTRY SCHOOL, C.1908. The Bell School at Klondike was a typical one-room country school, but from its students came successful businessmen, telephone operators with precise grammar, professional people, and other teachers. Pictured in this class, from left to right, are: (front row) Hubert McEver, Ferd Chamblee, Hoyt Smith, Herman Smith, Esther Jenkins, Miriam Hudgins, Wilder Mae Alexander, Avender Smith, Sena Wooten, and Albert Wooten; (middle row) Neva White, Dathan Bell, and Edward Bell; (back row) the teacher, Miss Linda Syfan of Gainesville, Ludalia Bell, Bobbie Smith, Ora Cobb, Earlie Dodd, Daisy McEver, Loduskie Hudgins, Alma Smith, and Effie Kaylor.

Seven

SCHOOLS AND COLLEGES

Northeast Georgia has a reputation for excellent schools at all levels. At the beginning of the century, most of Hall County's communities had elementary through high school institutions, many with dormitories, such as the Chattahoochee High School in Clermont.

Around the middle of the century, there was a statewide move to consolidate rural schools and Hall County formed three high schools, larger than the community schools and served by school buses. Gainesville had a separate school system and had four high school buildings during the century: Main Street School (which served all grades); the high school on Washington Street, near the square; E.E. Butler High School, which closed after integration; and the building at its present location.

Colleges and preparatory schools have also been an integral part of the local education scene. Riverside Military Academy, the Beulah Rucker School for Blacks, and, later in the century, Lakeview Academy, provided specialized learning for pre-college students.

It was in 1900 that the 22-year-old Georgia Baptist Female Seminary changed its name to Brenau College, and by the end of the 20th century it had become Brenau University. In the second half of the century Gainesville College and Lanier Tech were constructed on adjacent campuses in Oakwood.

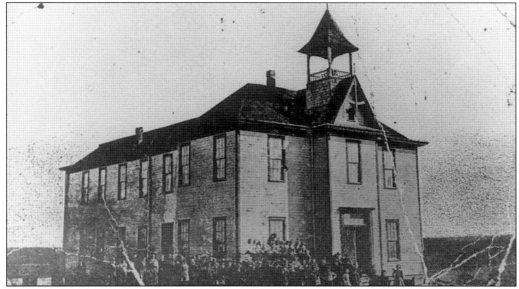

FLOWERY BRANCH SCHOOL. This school building was built around 1900, and was the second school located on top of the hill in Flowery Branch. Part of the second floor of this building was a Masonic Hall.

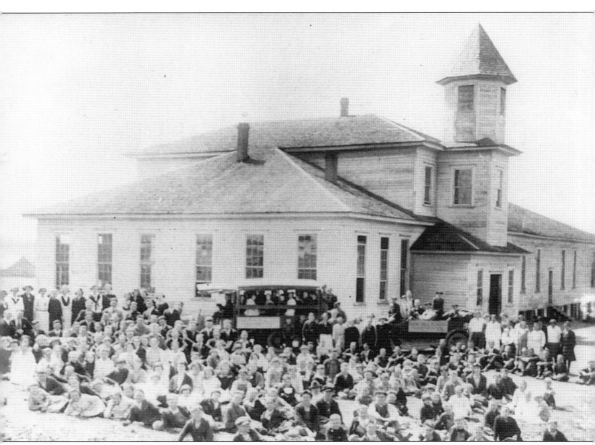

OAKWOOD HIGH SCHOOL. This building was constructed in 1911, and this photo taken *c.*1920. The school bus in the background is unique for the time; Oakwood is said to have owned the first school bus in Georgia.

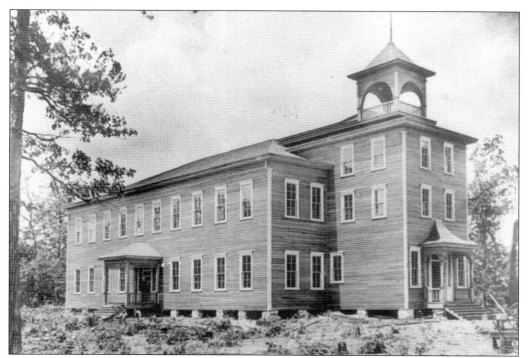

MURRAYVILLE HIGH SCHOOL. Around 1915 this private school was being promoted as a place where young men and women could "obtain a good education under the best of religious and rural surroundings." Both local and boarding students were accepted.

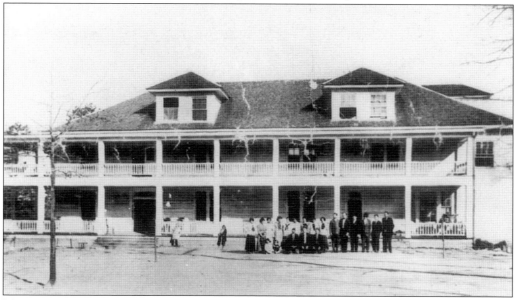

MURRAYVILLE HIGH DORMITORY. Boarding students lived in the Hosch Memorial Dormitory, named for Mr. Walter E. Hosch, of St. Louis, Missouri. It was not unusual in the era before school buses for rural students to live in a school dormitory and several area schools had such facilities.

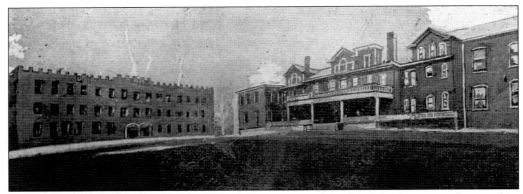

RIVERSIDE MILITARY ACADEMY. This military preparatory school for boys was chartered in 1906 and purchased by Gen. Sandy Beaver in 1913. The above photograph was taken from the streetcar station on Riverside Drive c.1913. The photograph below was made in 1919. Riverside had a winter campus in Hollywood, Florida, until 1984.

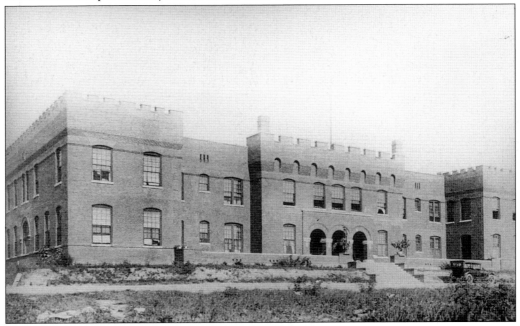

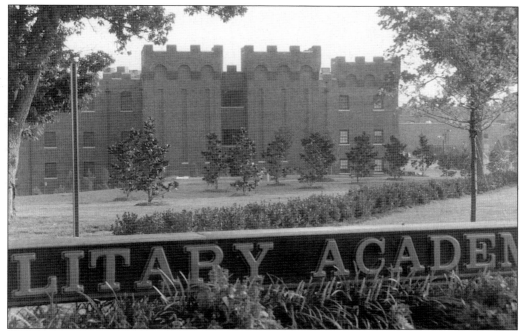

RIVERSIDE NOW. As the century ended, Riverside Military Academy was undergoing a multi-million dollar remodeling and expansion. With a positive worldwide reputation for academics, discipline, and leadership training, Riverside survived the 1960s when many military prep schools in the United States did not. The top photograph shows the new barracks at the main entrance. The bottom photograph shows the quadrangle inside the same building.

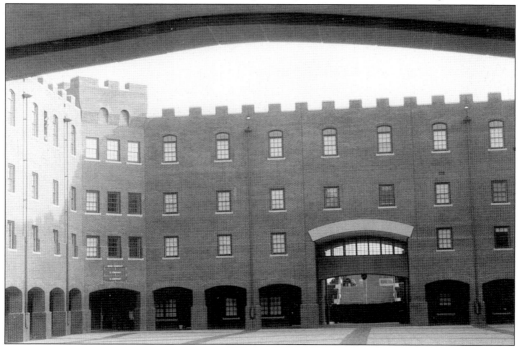

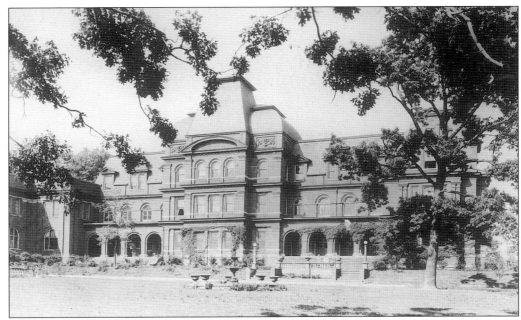

BRENAU UNIVERSITY. This school was founded in 1878 as the Georgia Baptist Female Seminary, and renamed the Georgia Female Seminary and Conservatory of Music in 1890. In 1900 it became Brenau College and Conservatory, and in the 1990s it gained university status. This is the administration building *c.*1925.

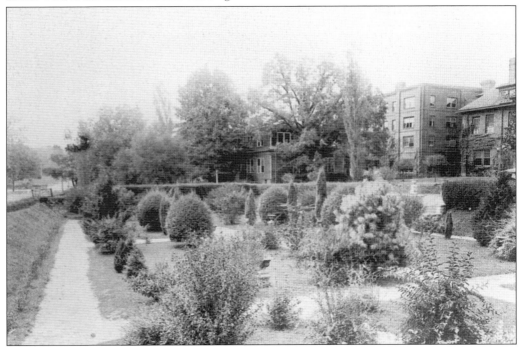

BRENAU SUNKEN GARDEN. One of Gainesville's show places early in the 20th century was Brenau College's sunken garden. This picture was taken about 1919.

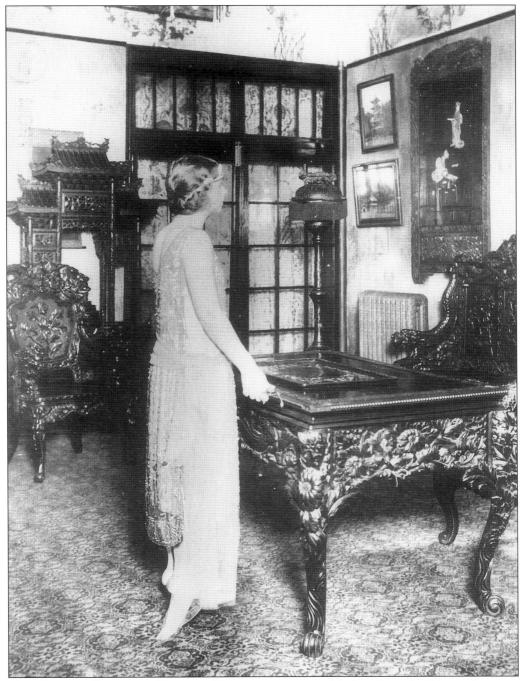

THE CHINESE ROOM AT BRENAU. This ornate room, with its classical Chinese furniture and fixtures, was the location for visits by many dignitaries to Gainesville up until the middle of the century.

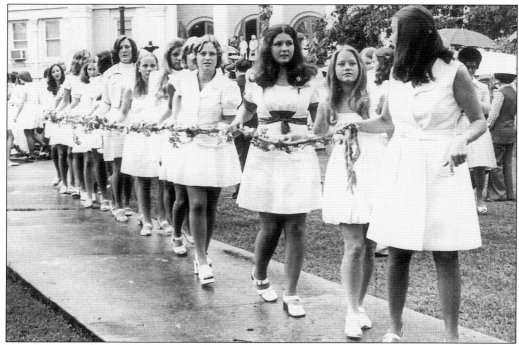

TRADITION. Brenau has many traditions, some now more than a century old. One of the most revered traditional events is May Day. This is the May Day procession in 1975.

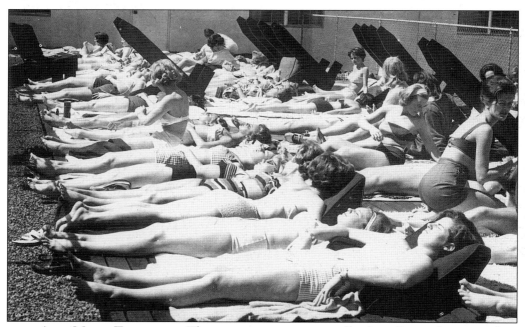

. . . AND MORE TRADITION. There are many ways to tell when Spring has arrived in Gainesville, but none is more certain than when sunbathing begins at Brenau. This photo was taken in the early 1960s with girls wearing the new, bold two-piece swimsuits.

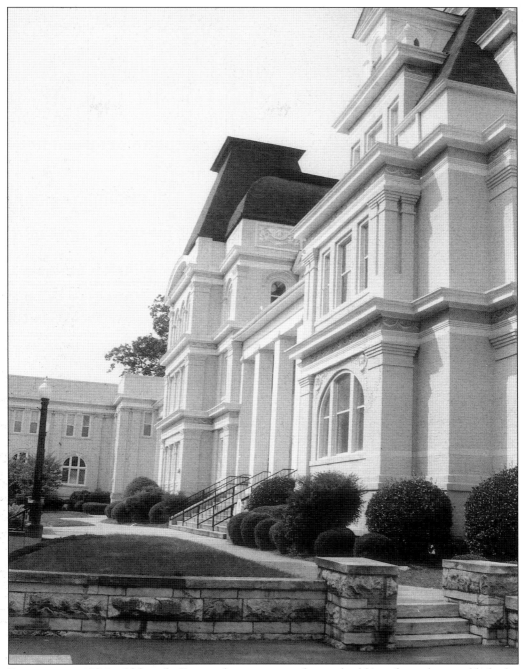

BRENAU IN 1999. Although Brenau has grown and new buildings have been added, the administration building, which contains Pearce Auditorium, remains the focal point of the main campus. The ornate Pearce Auditorium, completely restored, followed the design of European Theaters of the late 1800s with circular seating, boxes, and a dress circle. Generations of Gainesvillians have attended cultural events in the auditorium only to be entranced by the massive ceiling mural called *Aneas at the Court of Dido*.

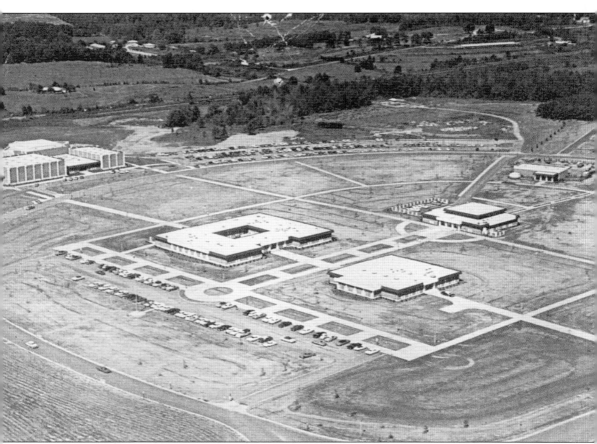

GAINESVILLE JUNIOR COLLEGE. As a part of the expansion of community colleges in Georgia, Gainesville Junior College was established by the University System of Georgia in 1964. Although they were part of separate school systems, Gainesville College and Lanier Tech were built on adjacent campuses, a great advantage to students in this area. This photograph shows the Oakwood campus shortly after opening, probably in 1965.

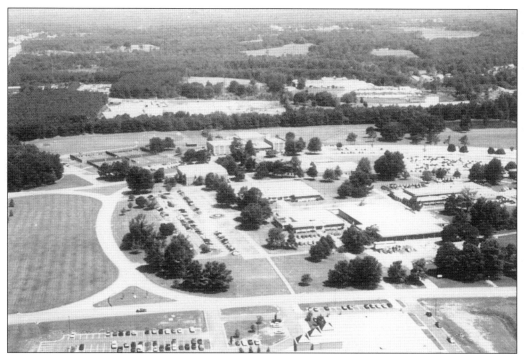

GAINESVILLE COLLEGE, C. 1990S. Not only have the trees grown, so have the buildings on campus and the student body. Although the college remains a two-year institution, degree courses may be taken in cooperation with North Georgia College and Southern Polytechnic Institute.

LANIER TECH. Designed to give students specific skills for the working world, especially in an era of developing technology, Lanier Tech also focuses on adult literacy. Since the 1990s, this school has also had a high-tech campus in Forsyth County.

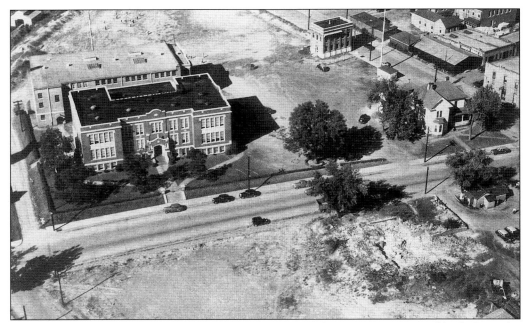

GAINESVILLE HIGH SCHOOL, C.1944. Located on Washington Street, one block from the square, Gainesville High survived the Tornado of 1936, even though almost everything around it was destroyed. The school building was eventually torn down, but the gym of '36 was converted into an office building.

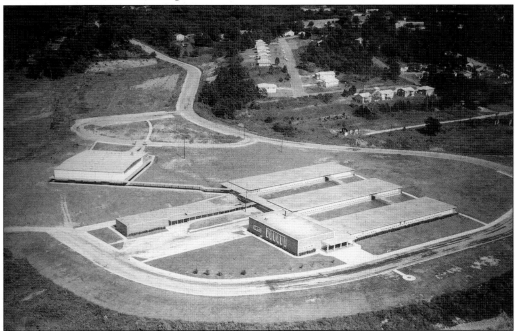

THE NEW GAINESVILLE HIGH. A new Gainesville High School building, following the one-story style then in vogue, was built in 1957. This aerial photo was made shortly after construction was completed.

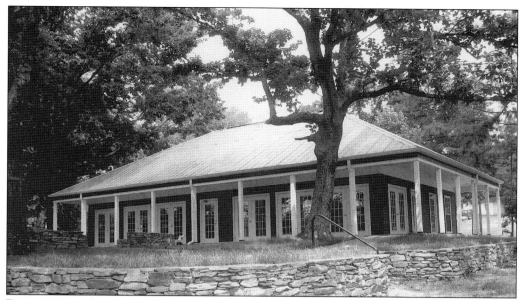

BEULAH RUCKER MUSEUM. The Beulah Rucker story is legendary in local education circles. She believed in a good education and a strong work ethic for blacks in the early 1900s, when educational opportunities for her race were limited. This remodeled replica of her school, located on Athens Highway, is now a museum in her honor.

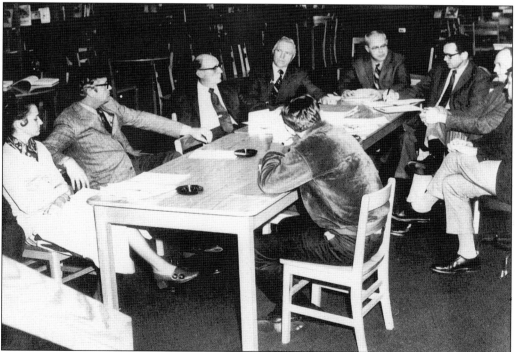

LAKEVIEW ACADEMY. Founded in 1970, Lakeview is an independent college preparatory day school serving 450 students. An early meeting of the trustees shows Chairman Dr. Robert Tether at the head of the table and Headmaster Woodrow Light at his right.

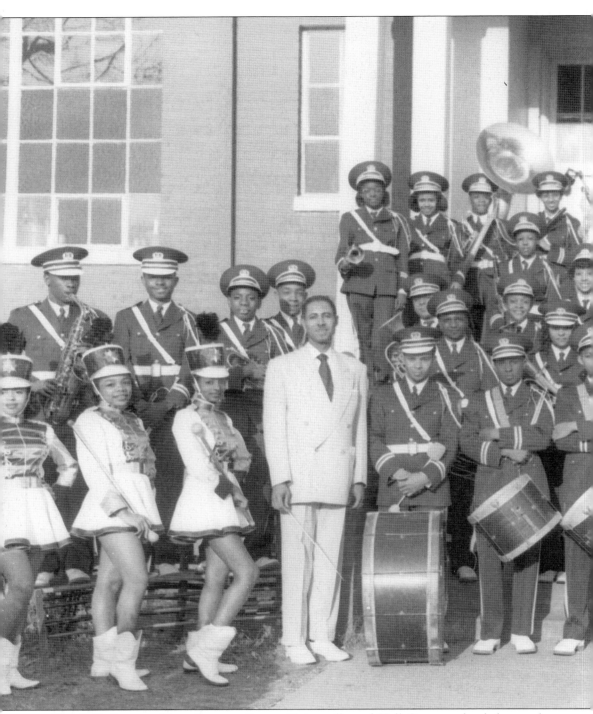

THE E.E. BUTLER HIGH SCHOOL BAND. Gainesville and Hall County schools have a long history of excellent music programs, but probably no musical group had a more loyal community-wide following than the bands under the direction of Mr. Rufus Tucker.

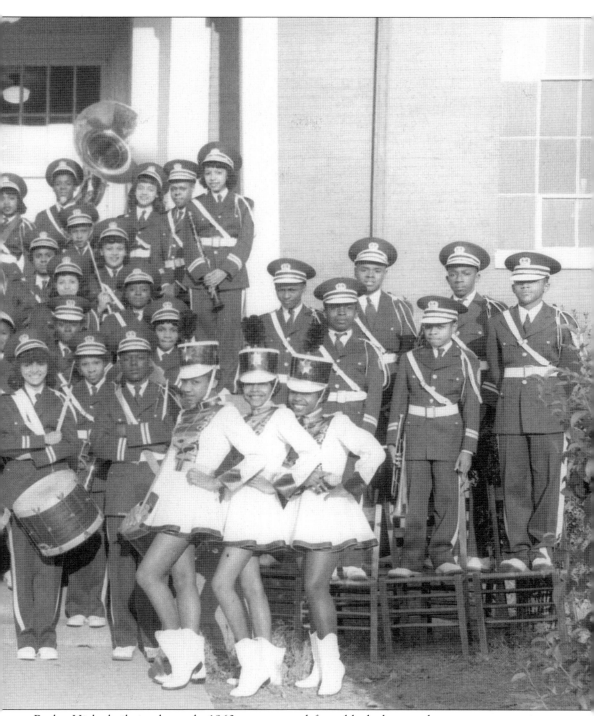

Butler High, built in the early 1960s, was named for a black doctor who was a community leader. With the coming of integration, students at E.E. Butler High and Gainesville High were merged into one school.

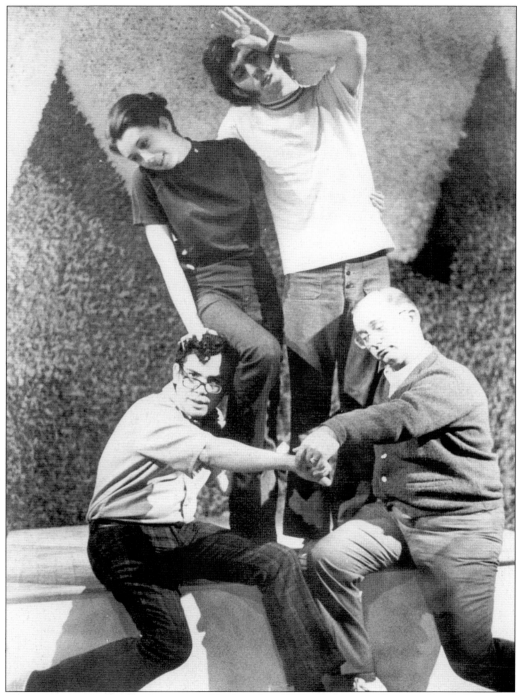

GAINESVILLE THEATRE ALLIANCE. During the 1979–80 season, Gainesville College and Brenau College formed the Gainesville Theatre Alliance under the direction of Ed Cabell (lower left in above photograph). The program has won numerous state, regional, and national awards.

Eight
ART AND CULTURE

Possibly because of its early days as a summer resort, or more likely the influence of institutions of higher education—whatever the reasons—Gainesville during the 20th century has had an abundance of art, crafts, and cultural activities.

Early in the century, Hall County was known for its functional pottery, and Gainesville's Brenau College as a music conservatory. Ed Dodd held national recognition as a cartoonist, and A. Wolfe Davidson as a sculptor.

In 1990, the Gainesville Theatre Alliance, a blending of Gainesville College and Brenau University drama talents, won the top national award at the American College Theater Festival. Under the direction of Ed Cabell, the local theater group is the only theater in Georgia ever to be a national winner. Art and cultural activities are an integral part of life in Gainesville and Hall County.

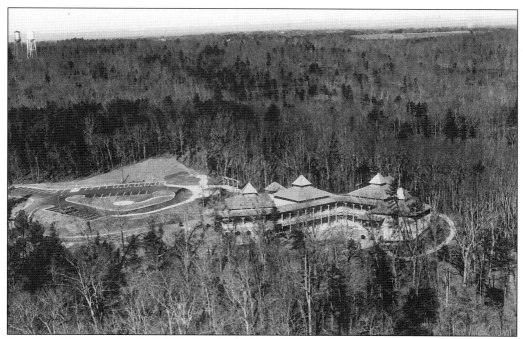

ELACHEE NATURE SCIENCE CENTER. Founded in 1978, Elachee's museum is located on the 1,200-acre Chicopee Woods Nature Preserve and is part of one of the largest parks within city limits east of the Mississippi. The area also includes a public golf course and an agricultural center. It was given to the community by Johnson and Johnson.

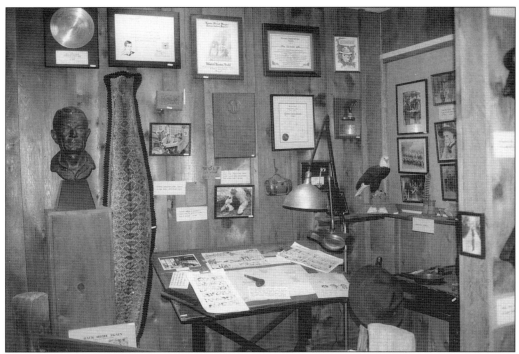

MARK TRAIL'S HOME. The creator of Mark Trail, the nationally syndicated conservation comic strip, Ed Dodd called Gainesville home. A room of Dodd's memorabilia is located in the Georgia Mountain History Museum at Brenau University. Since Dodd passed away, the strip is being carried on by another Gainesvillian, Jack Elrod.

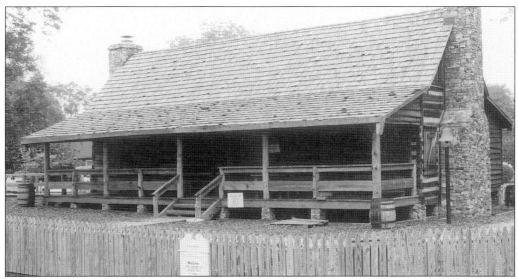

CHIEF WHITE PATH'S CABIN. This historic home of a Cherokee Chief has been restored and moved to the Brenau College campus, where it is a part of the Georgia Mountain History Museum. In addition to the Dodd and White Path exhibits, the Mountain History Museum includes displays about the textile industry, poultry business, and the area in general.

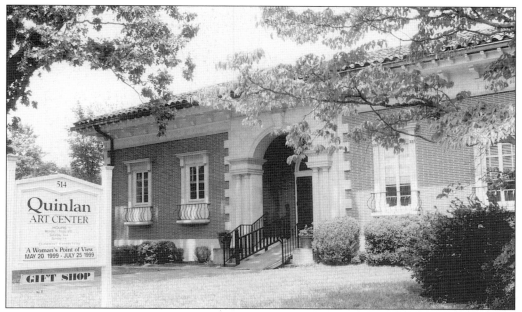

QUINLAN VISUAL ARTS CENTER. "The Quinlan," built in 1964, was the gift of a local businessman interested in the visual arts. With strong local support, it has a continuing series of art exhibits, classes, and workshops for all ages, and a gift shop where local art may be purchased. The Quinlan is located on Green Street.

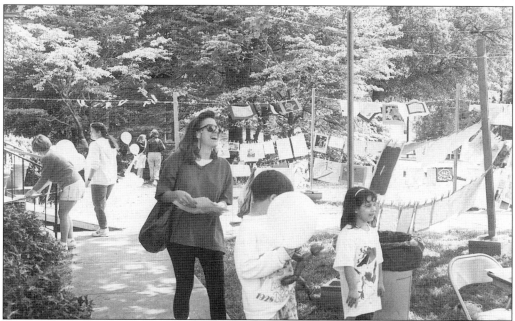

YOUTH ARTS FESTIVAL. Youngsters get the spotlight at a Quinlan Clothesline Art Exhibit, c. 1992. Summer art camps for youngsters have been a regular feature at the Quinlan from its beginnings.

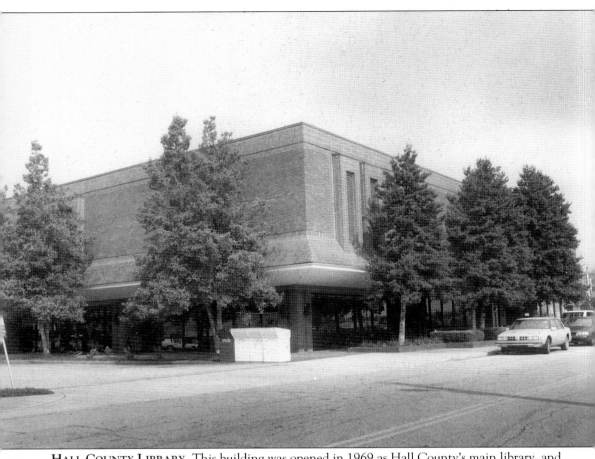

HALL COUNTY LIBRARY. This building was opened in 1969 as Hall County's main library, and is located in downtown Gainesville. Branch libraries are located in various parts of the county.

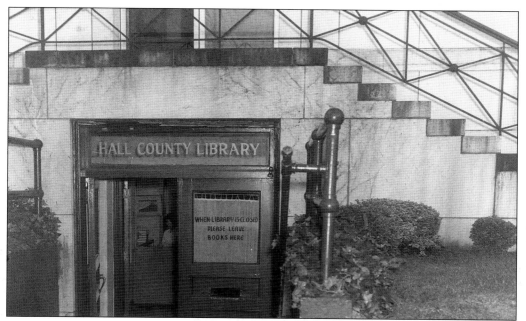

AT THE COURTHOUSE. During the 1940s and until the new library was built in 1969, the Hall County Library was located in the basement of the courthouse.

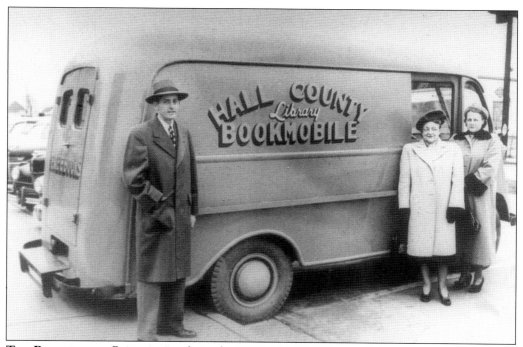

THE BOOKMOBILE. Beginning early in the 1950s, the Hall County Library ran routes and took books to the people. A highly popular service at the time, it was eventually replaced by branch libraries and improved transportation.

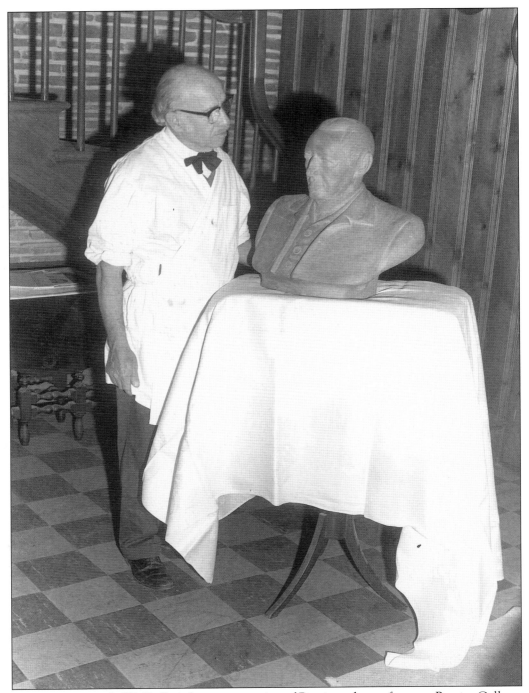

ABE DAVIDSON. A. Wolfe Davidson was a native of Russia and a professor at Brenau College. He was nationally recognized for the busts he did of famous people during the middle of the century, such as Senator Richard Russell of national fame and Jesse Jewell (see p 103) locally.

GAINESVILLE ARTS COUNCIL. The umbrella organization for area arts organizations, the council remodeled and expanded the old Gainesville Midland Railroad Depot. The building is located downtown, on Spring Street. Concerts and events are held both in the building and on the lawn in front of this entrance.

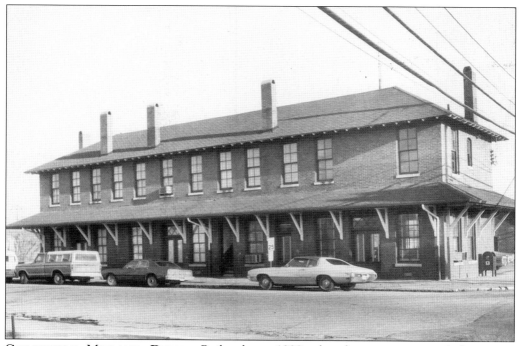

GAINESVILLE MIDLAND DEPOT. Built about 1920, the depot was one of downtown Gainesville's declining historic landmarks when the arts council acquired and remodeled it.

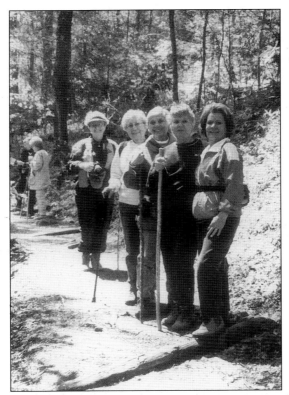

BULLI. The Brenau University Learning and Leisure Institute, fondly dubbed BULLI, offers a variety of courses and activities primarily intended for retirees. Although most courses are academic in nature, BULLI also offers activities such as this hiking adventure. Pictured resting on a deck at Devil Fork State Park are, from left to right: Doug Deane, Virginia Deane, Margaret Ellett, Lola Cunningham, Joyce Hope, Chris Nearing, Rosemary Freeman, Jim Nearing, Dick Freeman, Louise Bobzin, Jo Ann Hackle, and (standing) Margaret Hayman.

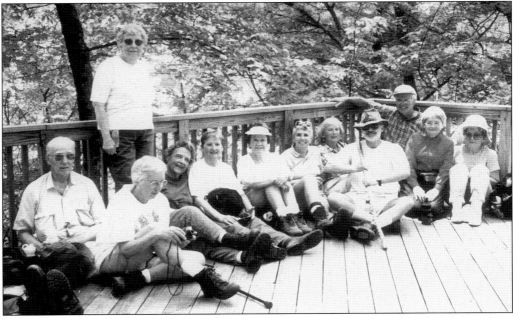

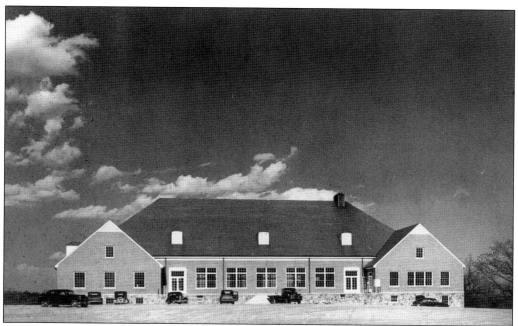

GAINESVILLE CIVIC BUILDING. Occupied about 1947, this structure was originally an armory and recreation building. It became the major large meeting facility for Northeast Georgia. It is pictured above about 1947. In recent years a porch has been added, and the building completely remodeled, as seen in the picture below.

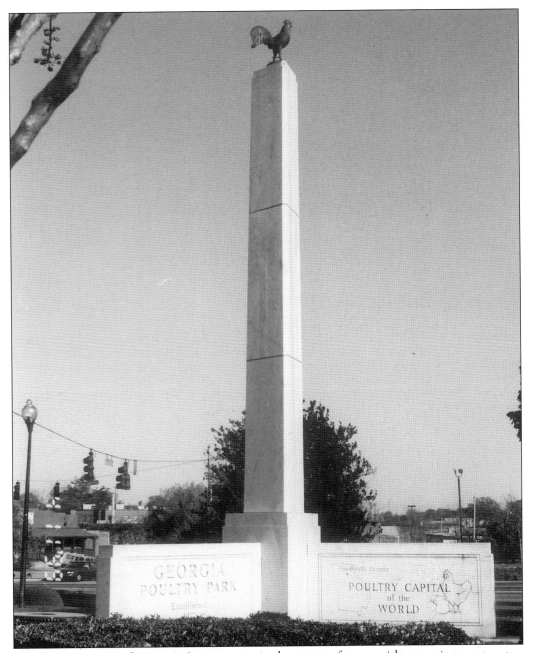

MONUMENT TO THE CHICKEN. A monument in the center of town, with a crowing rooster atop it, heralds Gainesville as the "Poultry Capitol of the World." From the middle of the century on, the poultry industry was the dominant contributor to the local economy.

Nine

AGENTS OF CHANGE

POULTRY, THE NATIONAL FOREST,
AND LAKE LANIER

Many factors have contributed to the changes experienced by Northeast Georgia during the 1900s: transportation and highways, education, health care, banking, the coming and going of the textile mills, the decline of cotton farming, and the development of a diversified industry. But three deserve special mention as the most influential agents of change—the development of the poultry industry, the acquisition of the Chattahoochee National Forest, and the impoundment of Lake Lanier.

Without the influence of these three elements, Northeast Georgia and Gainesville would be an entirely different place. In the following pages, you will see how they shaped the identity of a region and its people.

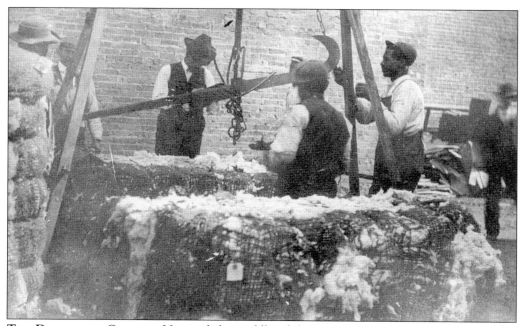

THE DECLINE OF COTTON. Up until the middle of the century, cotton was the leading cash crop for North Georgia farmers—each fall, towns were filled with farmers bringing bales of cotton from nearby gins. This photograph was taken in Commerce about 1905, but it could have been anywhere in the South.

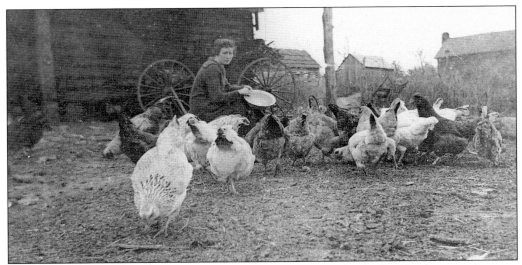

MAMA'S EGG MONEY. From the beginning there was a sizable chicken business in the area, fueled mostly by farm women who sold eggs and chickens to get household spending money. When they bought feed, they insisted on "print bags"—bags with cloth that was good enough to make clothes from, and had popular print designs.

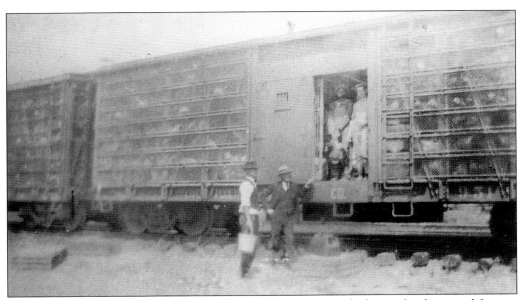

BUYING LIVE POULTRY, c.1924. Special railroad cars were parked near the depot and farmers brought farm chickens there. They were paid in script, which could be exchanged for goods at designated local stores. Workers rode the cars to major cities, feeding and watering the birds along the way.

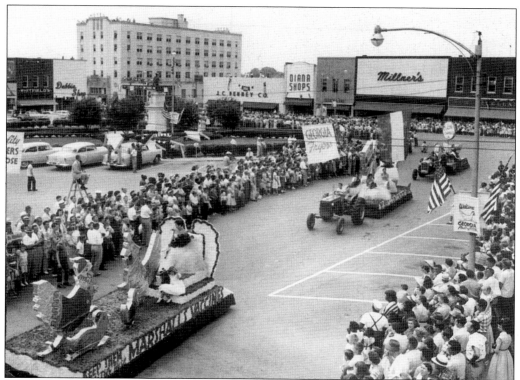

POULTRY FESTIVAL PARADE. Held in early Spring, the 20-block-long parade included industry floats, high school and college bands, and military marching units. Hospitality suites for visiting buyers were located mostly in the Dixie Hunt Hotel (visible across the square).

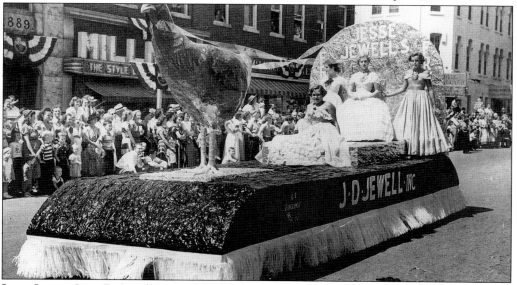

JESSE JEWEL. Jesse D. Jewell is generally credited with being the pioneer and leading promoter of the integrated poultry industry in North Georgia. He was also a pioneer television advertiser for poultry products.

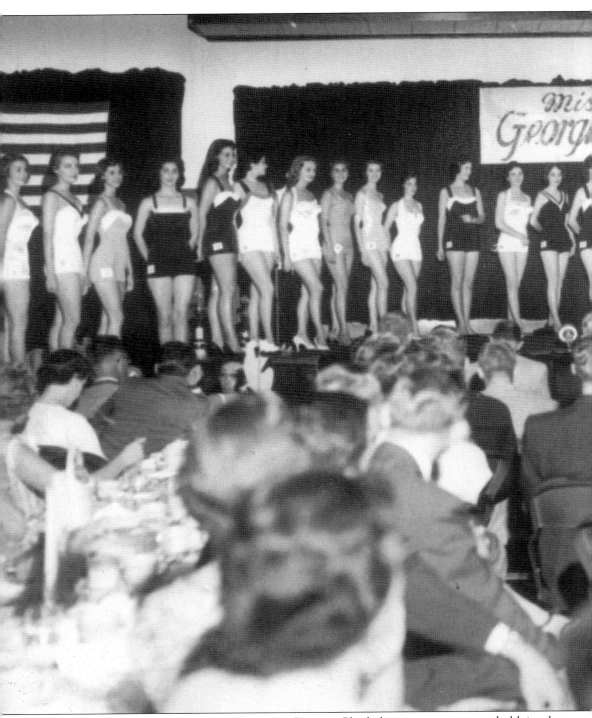

GEORGIA POULTRY FESTIVAL. The Miss Georgia Chick beauty pageant was held in the Gainesville Civic Building, *c.*1958. As cotton declined, the broiler industry filled the economic gap. In an effort to both encourage more local production and entice national chain store

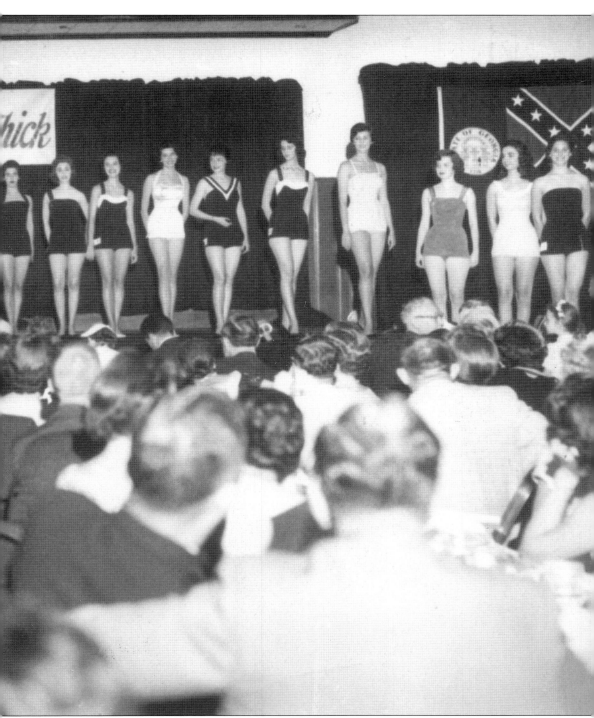

poultry buyers to favor Georgia, the promotion-minded Georgia Poultry Federation launched a series of annual Poultry Festivals insisting that "Wise Buyers Choose Georgia Fryers." Georgia became the nation's number one broiler-producing state.

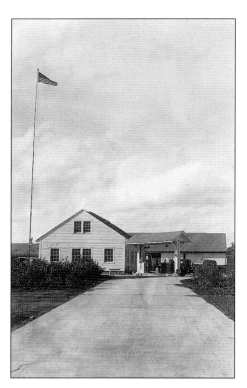

THE NATIONAL FOREST. The Chattahoochee National Forest eventually acquired almost 750,000 acres of land in mountainous North Georgia. The old Supervisor's office for the forest was located near Alta Vista Cemetery, in Gainesville. The first local office was located in the Hosch Building in 1936.

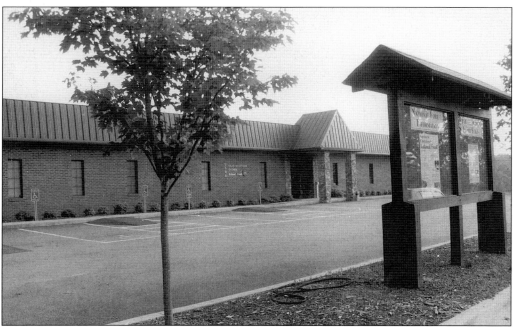

LOW PROFILE, BIG IMPACT. Although the National Forest generally carries a low profile, it has a major impact on forestry, tourism, and the economy of North Georgia. Present offices of the Chattahoochee National Forest are located on Cleveland Highway, in Gainesville.

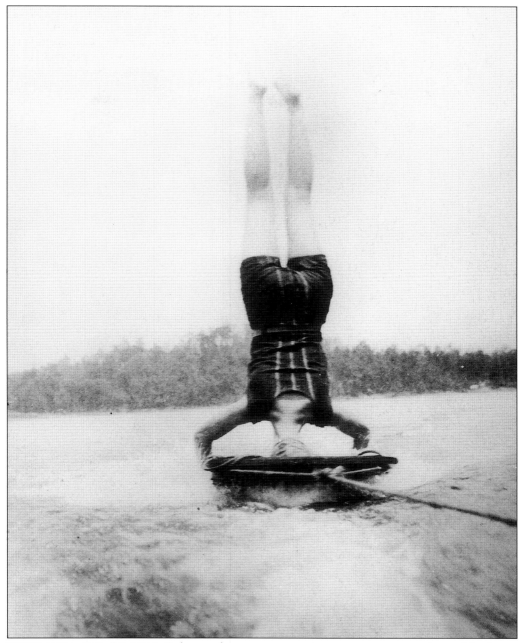

HIGHLANDS AND ISLANDS. Lakes and watersports are not new to mountainous Northeast Georgia. This photo of a young lady's headstand on an acquaplane was taken at Lake Rabun about 1925.

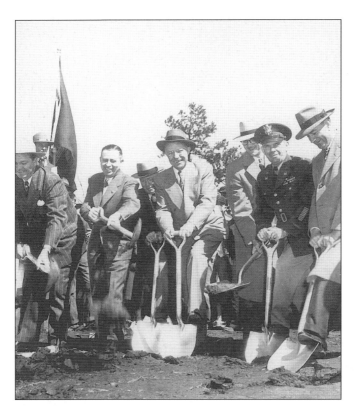

BUFORD DAM GROUNDBREAKING. Ground was broken for Buford Dam on March 1, 1950, and work was completed in 1957. Among those participating in the groundbreaking ceremony were, from left to right: Governor Herman Talmadge; Weldon Gardner, of the planning committee; E.L. Hart, Atlanta Freight Bureau; Mayor William B. Hartsfield of Atlanta; J. Larry Kleckley, president of the Gainesville-Hall Chamber of Commerce; Col. B.L. Robinson, Army Corps of Engineers; and Roy Otwell, Mayor of Cumming.

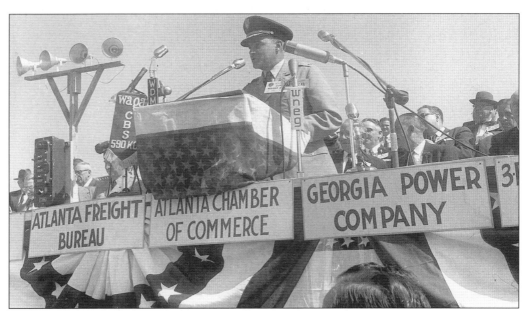

BUFORD DAM IS DEDICATED. After the dam was dedicated, with a large number of influential people on the stand, the focus turned to the lake itself and what could be done with it. Lake Lanier was named for the famous poet Sidney Lanier, author of "Song of the Chattahoochee."

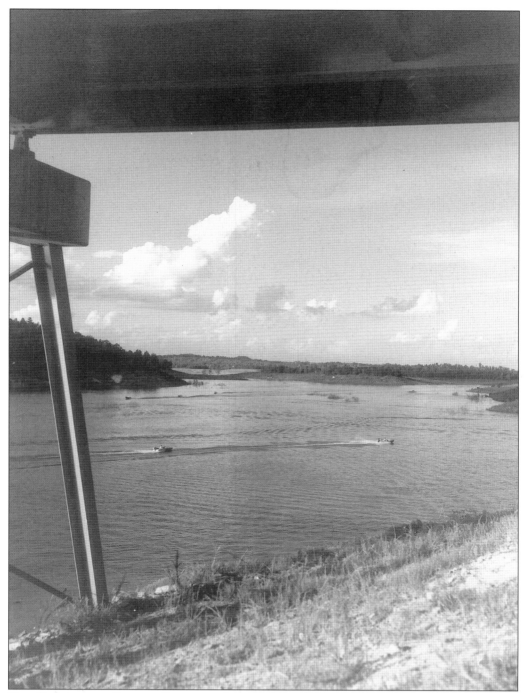

THE RECREATION BEGINS. Boaters and water skiers showed up on the lake as soon as water started backing up. Here two boats travel on the lake with treetops clearly visible above the water in the background. Other boats are visible in the distance.

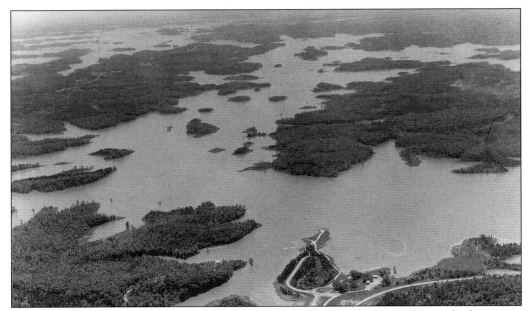

LAKE LANIER FILLS UP. As the lake filled it was allowed to cover trees until it reached a certain level, then treetops were cut and banks cleared up to the "full pool" level. Bottom land along the Chattahoochee River, the best farm land in Hall County, was covered by the lake. As the lake continued to fill, many of the islands seen here were covered.

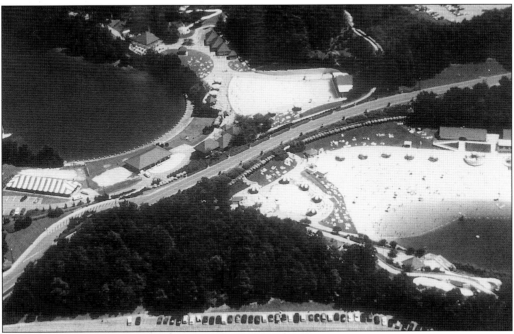

LAKE LANIER ISLANDS. A group of islands were made into a major resort area in the southern end of Lake Lanier. Shown here is a beach and recreation area. Built as a State Authority, the islands have since been privatized.

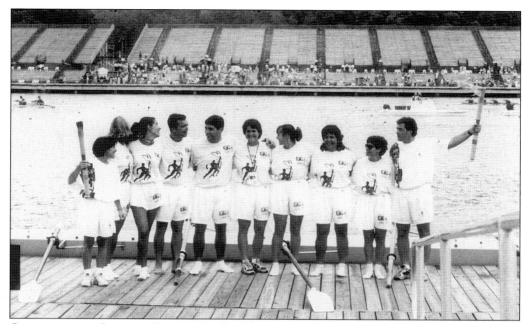

CARRYING THE OLYMPIC TORCH. As the Olympic Torch was carried across America, it came to Gainesville and was rowed across the Rowing/Kayaking venue. This photo shows torchbearers at the site. In the background, across the Chattahoochee, are the temporary spectator stands.

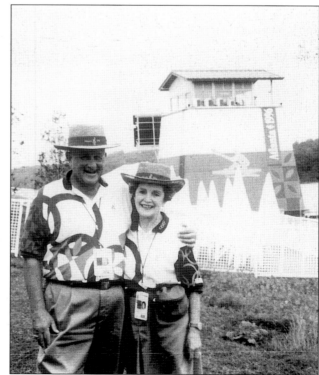

OLYMPIC VOLUNTEERS.
Hundreds of local citizens volunteered for Olympic service. Their uniforms were khaki slacks or skirts, colorful Olympic-ring knit shirts, and southern planter straw hats. Here Charles and Joanne Frierson pose in front of the finish tower.

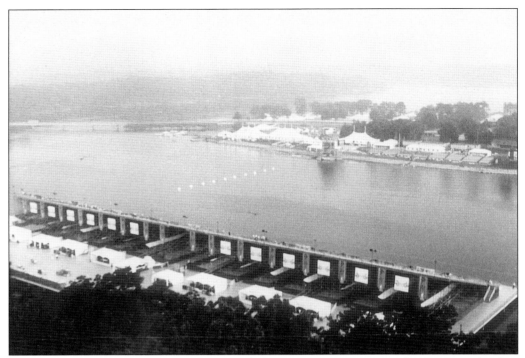

THE OLYMPIC VENUE. The temporary stands for spectators are seen in the foreground—they were torn out after the Olympics. The finish tower and competitors facilities can be seen across the water. White markers on the water show the finish line. Clarks Bridge is at far left, in the background.

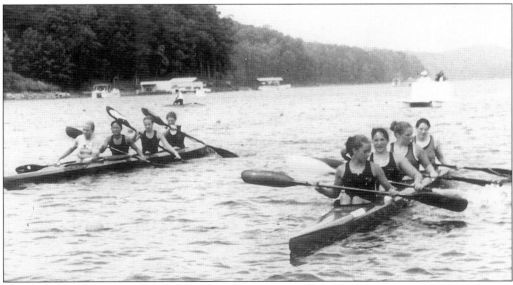

THE OLYMPIC LEGACY. The Olympics, as the organizers intended, left Northeast Georgia with a lasting legacy: one of the finest competitive rowing, kayaking, and canoeing facilities in the world. Here local youngsters take part in a post-Olympic competition.

Ten

THE WAY WE LOOKED, THE WAY WE LIVED

1950–2000

When Hall County's young men came home from World War II, they found an energetic trade center operating very much the way it had for the past 50 years. Gainesville had a rural flavor, for it served a mostly rural region—but change was on the way.

The poultry industry created a whole new economy, not just in Hall County but throughout the region. Lake Lanier not only brought money-spending visitors, it also lured landowners and residents. Hall County evolved from a quiet, mostly rural area to a more urban city with urban problems. The population doubled as we moved closer to Atlanta, and Atlanta closer to Gainesville.

Still, much of the original character remains: the mountains and lakes; Green Street and railroad stations; the parks and the airport; the churches, schools, and colleges; the emphasis on medicine and health; and the independent mountain attitude. For all the growth and change, it still has its own sense of community. In the photos that follow, you will see the way we looked and the way we lived as we moved through this transition.

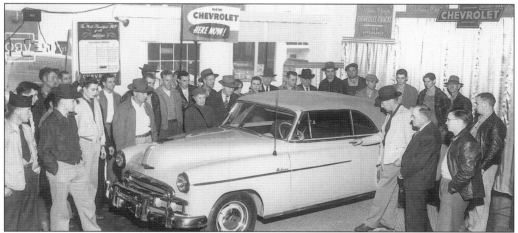

THE NEW CIVILIAN LIFE. By 1949, World War II was over and the troops were home, even though some still proudly wore remnants of their old uniforms. The focus of the times changed toward building a civilian life, and a point of interest was the introduction of the first new car styles since the early 1940s. This was the introduction of the 1949 Chevrolet sports convertible at Martin Motors in Gainesville.

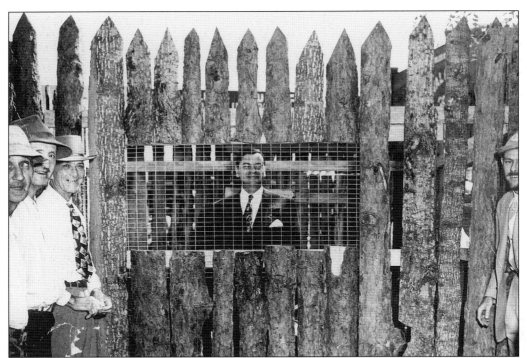

POLITICKIN'. Governor Herman Talmadge drove to Gainesville in 1951 to attend a fiddlers' convention, and they put him in a stockade on the Gainesville square. Mountain music was popular, so was "Hummon."

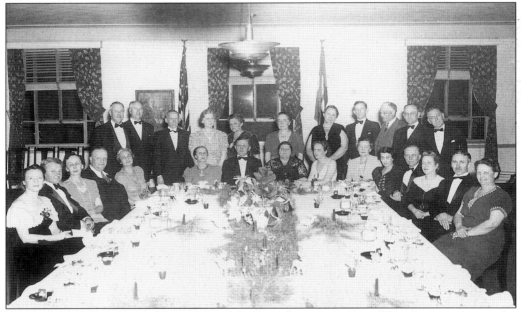

LITERARY CLUB, C.1945. This group of Gainesvillians met every Thursday evening in the ballroom of the Dixie Hunt Hotel to study current events and review literature. Clubs of this type became less popular and were phased out with the introduction of television.

AVIATION CONTINUES.
Airplanes continued to be a part of the Gainesville scene after World War II, and Dr. Homer Lancaster was one of the most ardent flyers as well as an aircraft dealer. Others included Lee Gilmer, Earl Pittman, and "Doc" Stow.

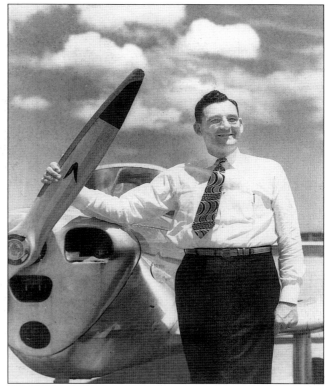

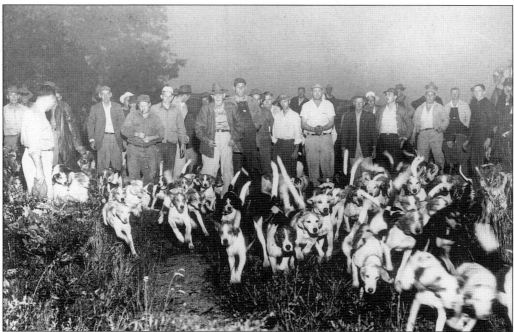

FOX HUNTING, C.1955. There was enough open land in Hall County for good fox hunting, and the sport had a good following.

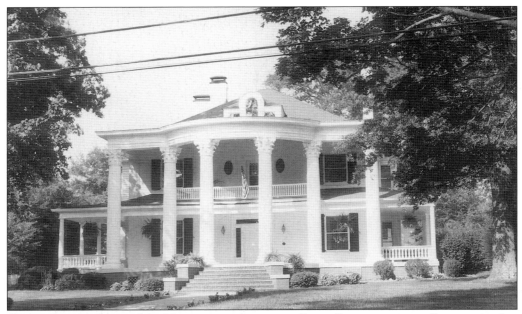

GREEN STREET. Most of the Victorian-era homes on Green Street remain, well-maintained as offices and business structures. The street is listed on the National Register of Historic Places.

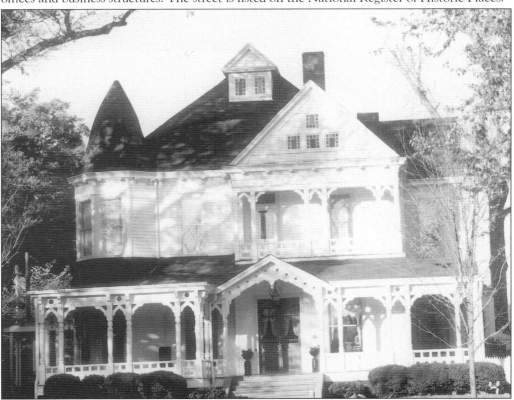

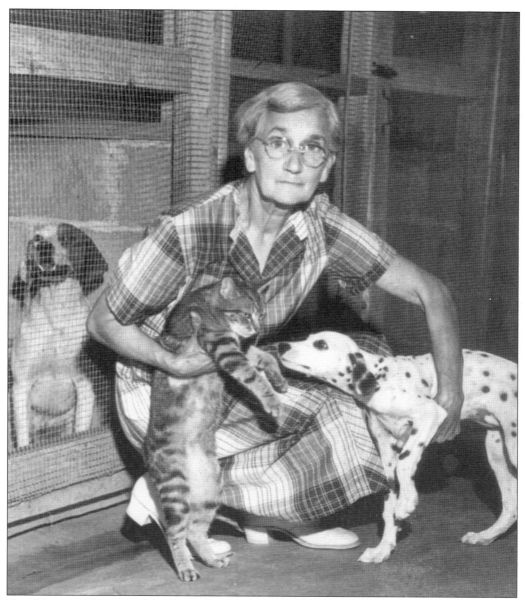

THE HUMANE SOCIETY. Miss Bessie Bickers became a legend in Gainesville for promoting the love of and care for animals. Founder of the Humane Society of Hall County, she also staged pet parades for children and other activities promoting the love of animals. This photo was taken about 1951.

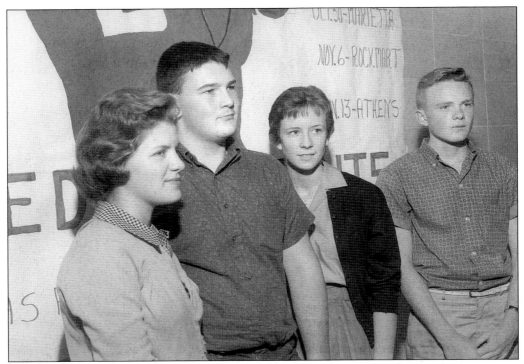

PRELUDE TO SPACE. Roy Bridges (right), a student at Gainesville High in 1961, became an astronaut in the U.S. space program and went to the moon. Class Officers in 1961 at GHS are pictured from left to right: Bonnie Kemp, James C. "Bimbo" Brewer, Winnie Lancaster, and Roy Dubard Bridges.

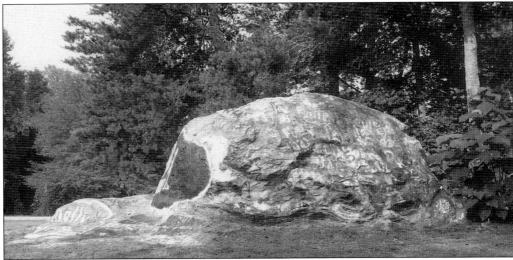

THE ROCK. This boulder, uncovered during roadwork near Gainesville High, became the center for pep rallies and other activities. More importantly, Gainesville High's cheerleaders paint slogans and challenges on the face of the rock. Other messages have been known to appear, too—from other schools, birthday well-wishers, and anyone who has a message, such as "Hooray! School's Out!" With literally thousands of coats of paint, the Rock is a local legend.

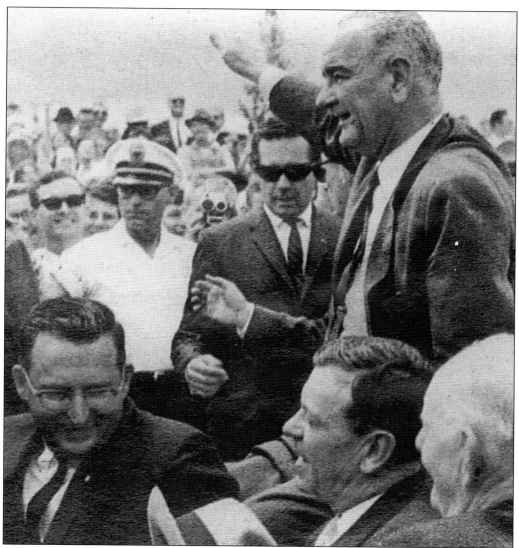

LBJ Close to the People. President Lyndon B. Johnson came to Gainesville in the 1960s to announce his "war" on poverty. Here he rides on the back of an open convertible through Gainesville Streets, as close to the people as his security guards will allow. Seated in the car at left is Gainesville Mayor Henry Ward and in the center is Senator Herman Talmadge.

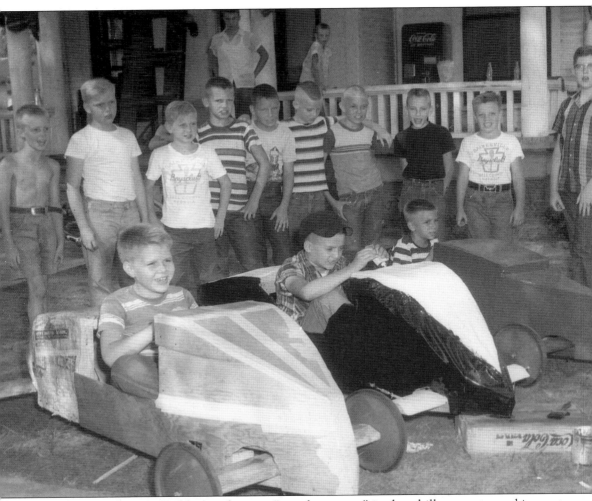

SOAP BOX DERBY. Building and racing "soap box racers" in downhill events was a big sport for young boys in the mid-1950s. Three Boys Club members show their cars, from left to right: Sammy Curtis, Herbie Young, and Bill Reeves. Looking on, from left to right, are: Larry Mauldin, Tex Mathews, Philip Latimer, Larry Jackson, Roy Burks, Larry Westbrook, and Perry DeLong.

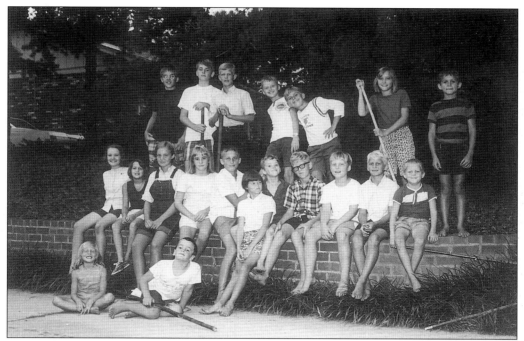

THE NEIGHBORHOOD IN SUMMER. During the 1960s, neighborhood youngsters in Gainesville gathered for "kick the can" or just to hang out. This group was photographed by Dr. Hamil Murray on Springdale Road. Pictured standing, from left to right, are: Mike Martin, Louis Sawyer, Bond Murray, Edwin Sawyer, Allen Martin, Elisa Norton, and Bob Norton. Seated on the wall, from left to right, are: Diane Teaver, Sloan Stribling, Ellen Smith, Carol Frierson, Warren Stribling, Lisa Waters, Robin Sawyer, Tom Murray, Tharpe Ward, Zack Murray, and Wade Stribling. In the foreground, from left to right, are: Paula Murray and Chip Frierson.

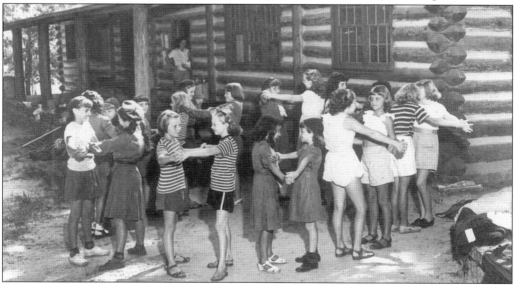

GIRL SCOUTS, C.1950. Summer camp for local Girl Scouts was held at the log cabin at Prior and Glenwood Streets, adjacent to City Park.

VANN'S TAVERN. This classic log house, built in 1905 by James Vann, a Cherokee Indian, was saved from Lake Lanier and moved log by log to New Echota in Gordon County. It was located on Federal Road near the Chattahoochee River, where Vann operated a ferry (later Winn's Ferry).

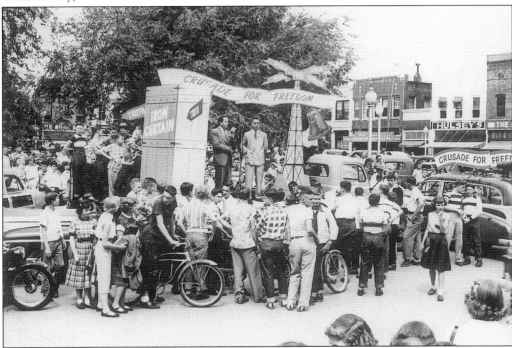

THE COLD WAR COMES HOME. By the 1950s, political emphasis had shifted to the Cold War against Communism, and the Crusade for Freedom promoted Radio Free Europe and Radio Free Asia, which sent broadcasts to Iron Curtain countries. Here, Gainesville young people gather on the square for a rally in 1951.

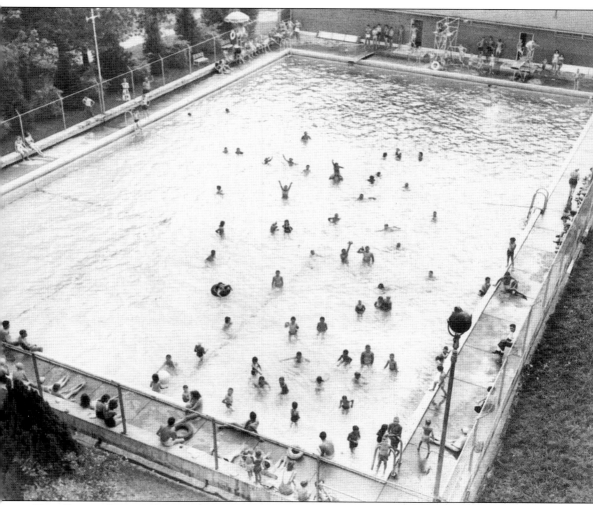

THE GREEN STREET POOL. The city swimming pool was more than a recreation spot in the 1950–1960 era. It was where young people met, learned to swim, and flirted, and where mothers socialized on hot summer days.

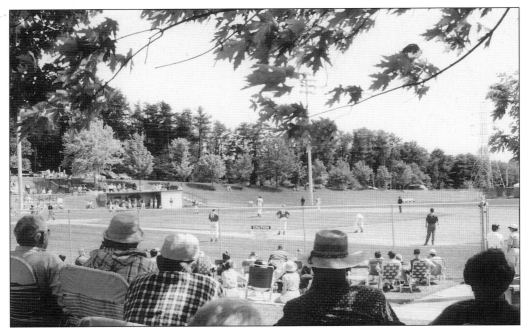

SPORTS IN GAINESVILLE. Early in the century the dominant sport in Gainesville, and America, was baseball. Then came football, along with basketball and golf. At the century's end, baseball is back in the limelight, and Gainesville has the finest baseball complex in the region—but a "newcomer," soccer, is gaining popularity.

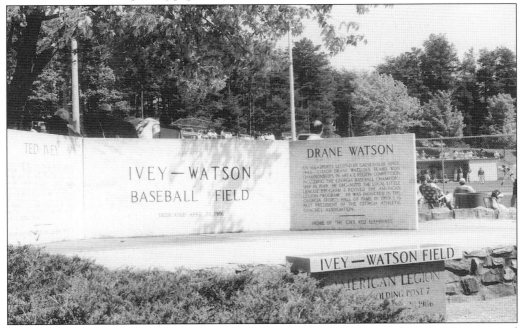

IVEY-WATSON FIELD. Named for two longtime coaches, Ted Ivey and Drane Watson, and supported by Post 7 of the American Legion, this public facility hosts baseball events for all of Northeast Georgia.

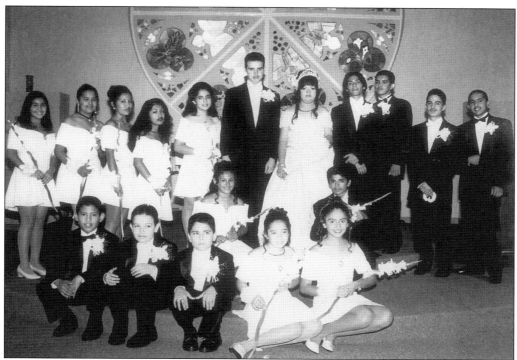

QUINCEANERA. During the 1990s, a growing Hispanic community brought new traditions to Gainesville, including the Quinceanera. In Hispanic tradition, when a young girl turns 15 she becomes a lady, and is honored with an event that includes a Catholic mass, a feast, a party, and a dance. This photo, made at St. Michael's Catholic Church, is courtesy of the Spanish-English newspaper, *Mexico Lindo*.

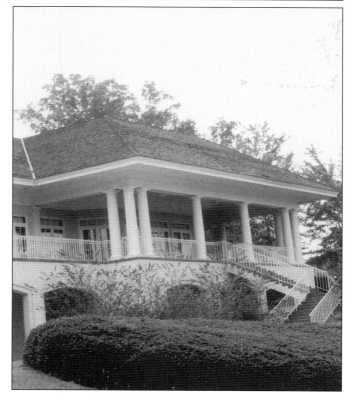

CHATTAHOOCHEE COUNTRY CLUB. Located on Lake Lanier, this club was formed c.1960. It was expanded when this new clubhouse was built in 1987.

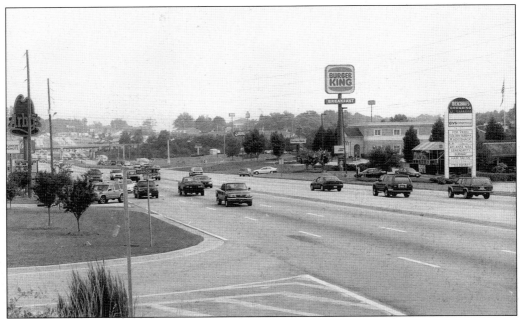

OAKWOOD. In 1999 it was estimated half the population of Hall County lived South of Gainesville, with Oakwood as its business center. This view is from near the entrance to Gainesville College, looking toward Exit 4 at highway I-985 (the overpass in the distance) where a major new highway is in the planning stages.

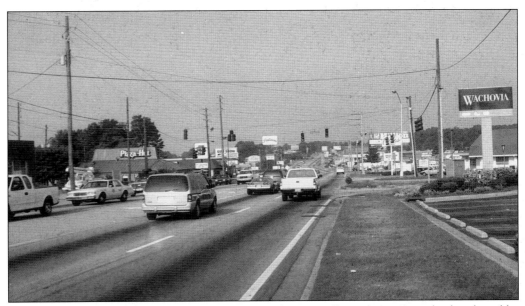

BROWN'S BRIDGE ROAD. The new retail center of Gainesville at century's end is bracketed by this thoroughfare, Pearl Nix Parkway and Dawsonville Highway. The preponderance of national retail chain stores, restaurants and building supply stores are located in this area. Brown's Bridge Road is home to most of the automobile dealerships.

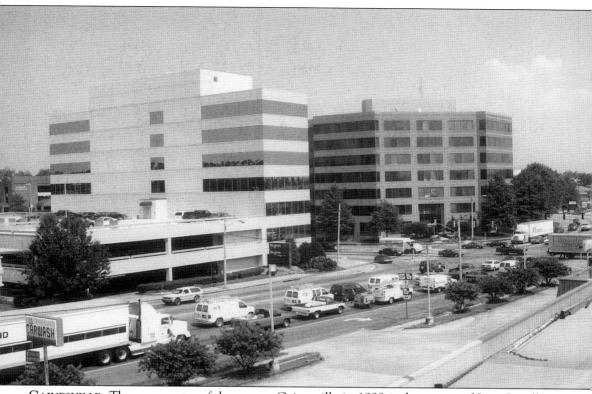

GAINESVILLE. The new center of downtown Gainesville in 1999 is the corner of Jesse Jewell and E. E. Butler Boulevards, pictured here. The traditional downtown business section is dominated by banking, government, the courts along with lawyer's offices, hotels and motels, and service businesses.

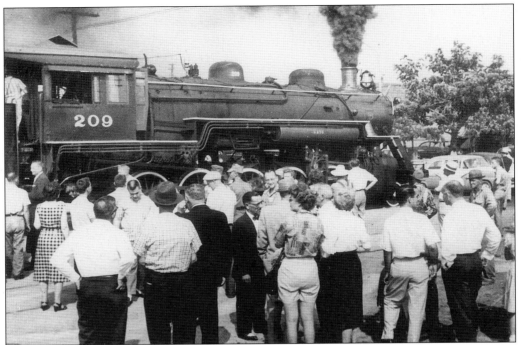

CENTURY IN REVIEW. The Gainesville Midland Railroad saw most of the 20th century—it was formed in 1904 from the Gainesville, Jefferson and Southern Railroad and ended as part of the Atlantic Coast Line. Steam locomotive #209 was built in America for the czar of Russia, but the order was canceled because of the 1917 Russian Revolution. It made its last run in 1959 (upper photo) and is now housed in Railroad Park in downtown Gainesville.

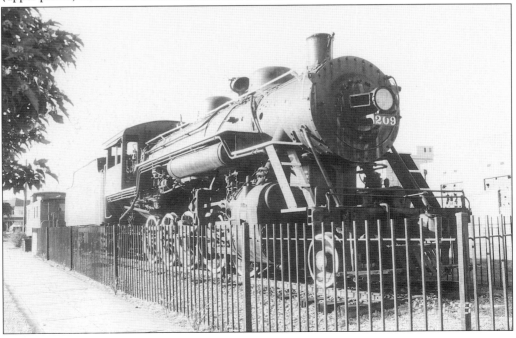